LANCASTER

THE POSTCARD COLLECTION

BILLY F. K. HOWORTH

AMBERLEY

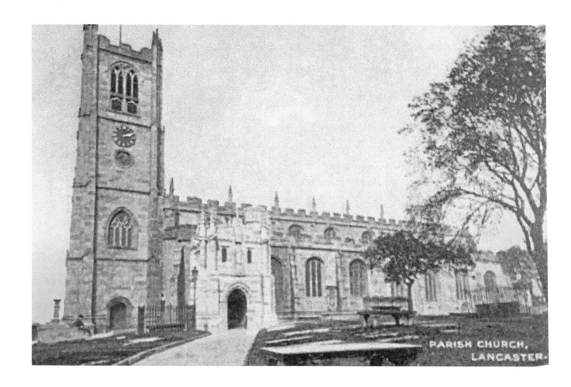

In memory of my Grandma, Meda Whittle (1937–2013)

First published 2017

Amberley Publishing
The Hill, Stroud, Gloucestershire, GL5 4EP
www.amberley-books.com

Copyright © Billy F. K. Howorth, 2017

The right of Billy F. K. Howorth to be identified as the
Author of this work has been asserted in accordance with
the Copyrights, Designs and Patents Act 1988.

ISBN 978 1 4456 6850 5 (print)
ISBN 978 1 4456 6851 2 (ebook)

British Library Cataloguing in Publication Data.
A catalogue record for this book is available from the
British Library.

Typesetting by Amberley Publishing.
Printed in Great Britain.

CONTENTS

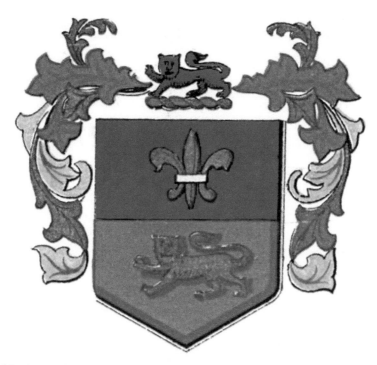

CASTLE GATEWAY,
100 YEARS AGO. LANCASTER.

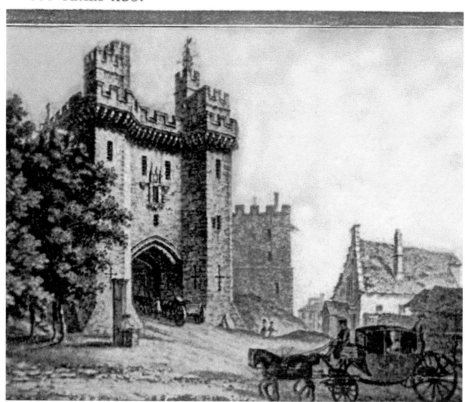

INTRODUCTION

When the Romans first settled in the area almost 2,000 years ago, few could have imagined the epic history of the town that has unfolded since then. In my own opinion, Lancaster has a fascinating history that encompasses some of the most important events ever seen in British history.

The story of Lancaster begins during the period of the Roman conquest. The foundation of Lancaster's Roman fort was probably at the request of Quintus Petillius Cerialis who was the Roman governor of the province between AD 71 and AD 74. The location of the site was very important as it had a clear vantage point of the area with the river, sea and surrounding land all visible from the fort. This location over the centuries became known as Castle Hill. The fort remained in use until the early fifth century, after which the Roman Empire began to go into decline, eventually falling around AD 476. After this period the fort was abandoned and left to fall into ruin.

Around 1090 on the same site as the Roman fort once stood, Roger de Poitou, who was given the Honour of Lancaster, set about developing the town, building the castle and later the priory. For the next few centuries the castle would continue to be developed and also play a key role in national events including the Wars of the Roses and the Pendle Witch Trails.

By the time we get to the eighteenth century, Lancaster had begun to expand rapidly and was becoming a very important town within the North West. The growth of the town was the product of increased British involvement in the North Atlantic Slave Trade, and Lancaster entered into this in 1749 with an Act of Parliament, which set up the Port of Lancaster Commission. Within a few years the town had constructed a new quayside, complete with customs house, warehouses and new shipyards. All of this in addition to the merchants in the town meant that within a few decades Lancaster had grown to be the fourth largest port in Britain involved in the slave trade. The growth in this new trade also led to the creation of one of Britain's most celebrated furniture manufacturers, Gillows of Lancaster, whose work became so sought after that they exported it around the world.

However, Lancaster's time in the limelight was coming to an end and the final nail in the coffin came in 1807 with the abolition of slavery. After this period the port fell into decline and it would take a few more decades before the town regained its reputation. It was during the 1840s that James Williamson Snr founded a company in the town that produced coated fabrics. His son, later known as Lord Ashton, grew the business dramatically and constructed a huge factory known as Lune Mills, a company that survived into the mid-twentieth century.

During the twentieth century Lancaster underwent numerous changes like many British cities at the time. Many notable old buildings were demolished, streets disappeared and some of the heritage was lost. However, we are still very lucky that many of the finest buildings still survive to this day, especially Lancaster Castle and Priory, the Georgian houses on Castle Hill, two impressive town halls and the monumental Ashton Memorial.

Finally, I would like to say that this book would not have been made possible without the work of many different artists and photographers who, over the past century, sought to promote the town and its sites through the production of picture postcards. The postcards featured in this book come from my own personal collection, and I have attempted to give a full overview not just of the city and how it has changed, but also link it to the surrounding villages and the contrast in living conditions.

TOURIST POSTCARDS

LANCASTER.

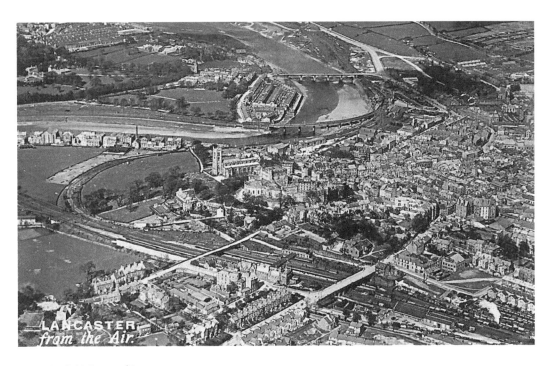

Aerial Views of Lancaster

Very few postcards of Lancaster show the city and surrounding area from the air. The city has always been constrained by the geography of the area, nestled between two hills and the River Lune, all of which have shaped the way in which the town has grown and expanded over the centuries. These images give us an interesting insight into how the landscape has been used to create some of the most iconic buildings in the town.

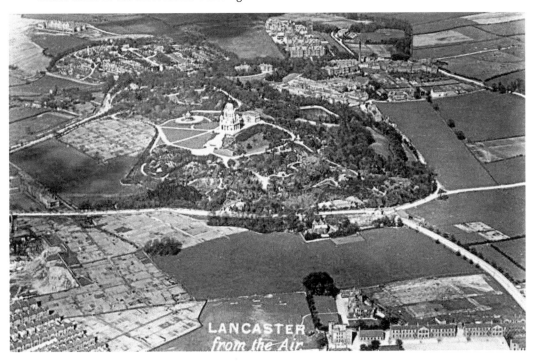

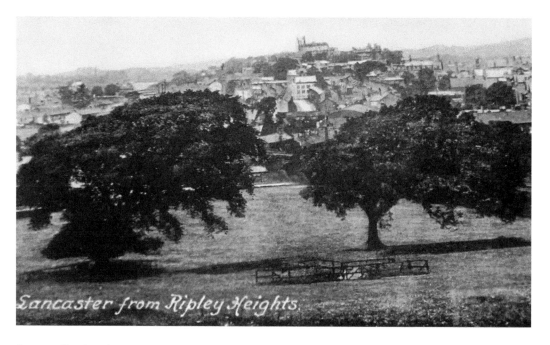

Lancaster from Ripley Heights.

Surrounding Landscape

The landscape surrounding Lancaster is a combination of marshland, farmland and forest and is one of the main reasons that for hundreds of years the town remained fairly isolated and cut off from the rest of the country. It was only with the creation of the toll roads, the canal and the opening of the first railway in Lancaster in 1840 that allowed the town for the first time to be connected easily with other parts of the North West and further afield.

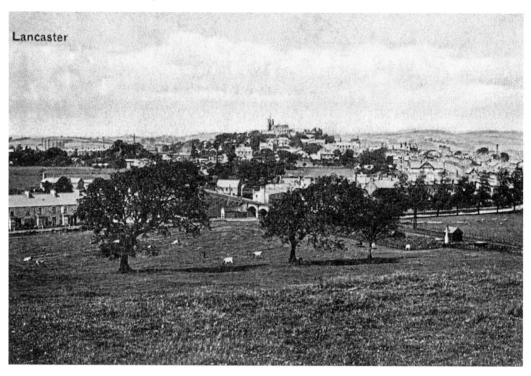

Lancaster

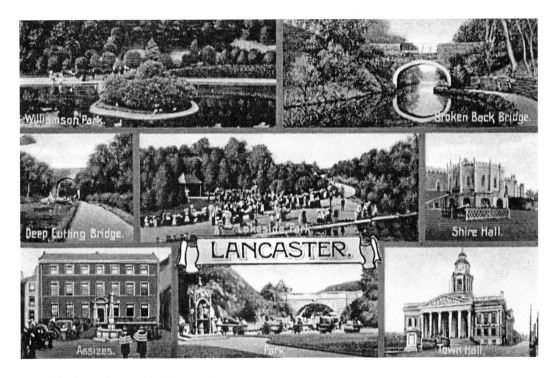

Multiview Postcards of Lancaster

With the coming of tourists to the town during the Victorian and Edwardian period, the idea of promoting the history of the town through images was first used. These multiview postcards show a selection of the most famous sites that were to be found within the town, ensuring that visitors would attempt to see as many as possible on their visits.

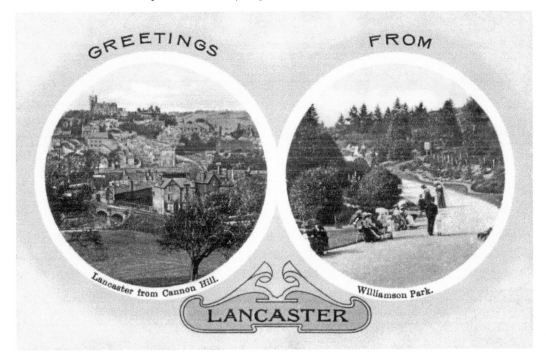

9

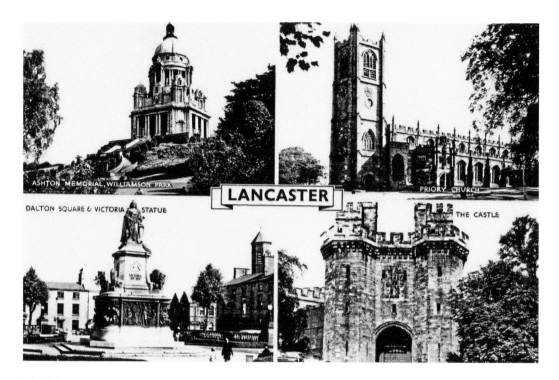

Multiview Postcards of Lancaster II

Tourism during the Victorian period and early twentieth century was aided by the ability to create mementos and souvenirs that visiting tourists were able to purchase and take home with them. Many companies were created around this, especially focusing on the taking of photographs and creation of postcards, and Lancaster was no exception. These postcards were created not just in greyscale, but also later produced in colour due to advancements in mass-produced coloured printing.

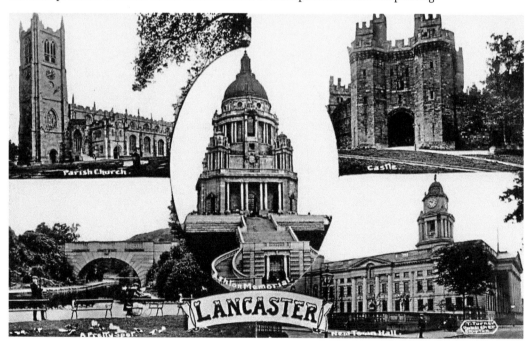

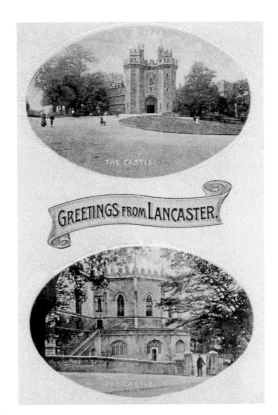

Lancaster's Heritage

When you take a look at the tourist postcards produced for the town, heritage has always played an important part. One of the most important emblems you find is the coat of arms for the town. In addition to this the castle is arguably the most prominent building found on postcards due to its age, interesting history and also its connection with the reigning monarch and British history.

LANCASTER.

Chapter 2
ALONG THE RIVER LUNE

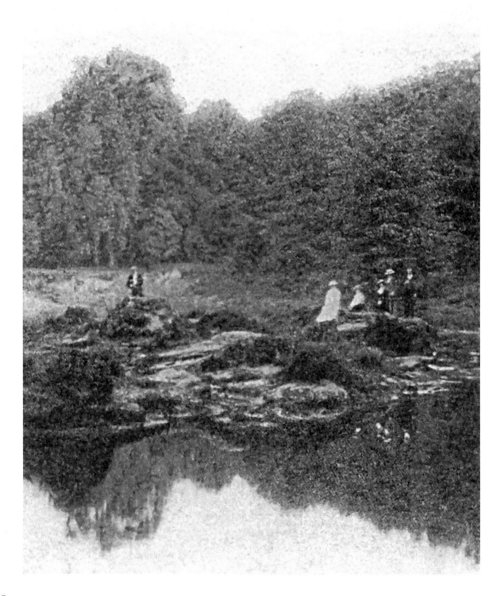

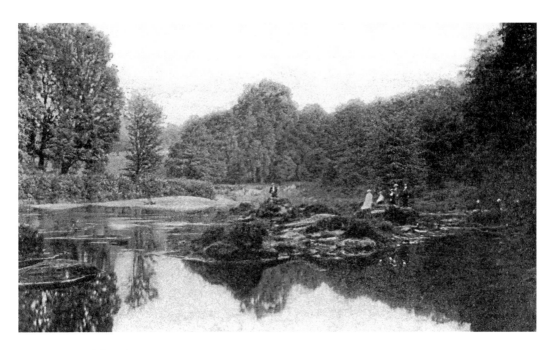

Views of the River Lune

When we take a look at the local landscape in the area, there is one feature that has played a major part in local history – the River Lune. The Lune has shaped the way Lancaster and the local district has developed throughout the centuries, serving as a vital artery to Morecambe Bay and the Irish Sea. It has provided food, power and a route for transportation, allowing cities, towns and villages to thrive in the process. The source of the river originates not in Lancashire but in Cumbria at Wath, located in the parish of Ravenstonedale. The river is formed at the point where Weasdale Beck and Sandwath Beck meet.

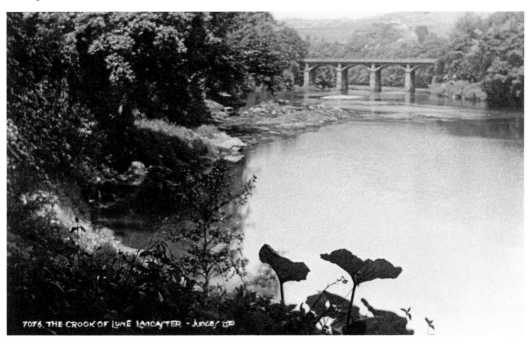

7076. THE CROOK OF LUNE LANCASTER - JUDGES LTD

Views of the River Lune II

As the river moves downstream along its 44-mile route, it passes many ancient sites including the remains of a Roman fort close to Low Borrowbridge, through the Lune Valley and Lancaster out towards the Lune Estuary where it meets the sea at Plover Scar. Originally the Lune was a tidal river; however, since the construction of Skerton Weir, the river can no longer travel further inland at high tide.

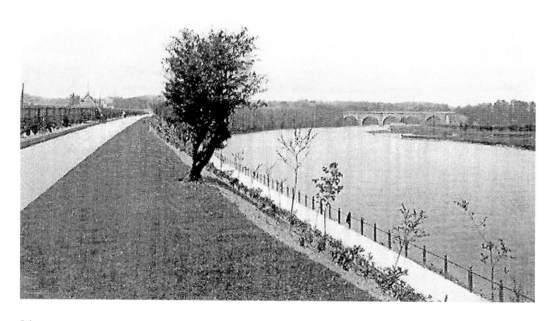

LUNE BANK GARDENS LANCASTER

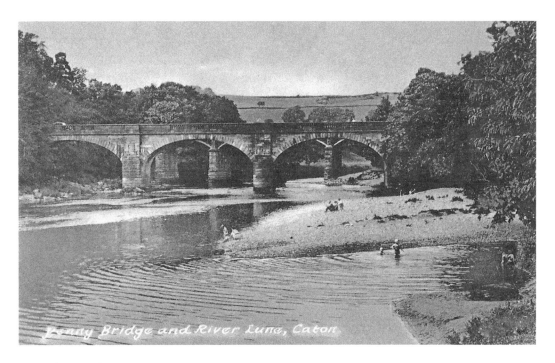

Penny Bridge and River Lune, Caton

The Crook O'Lune

Near to Caton, around 5 miles upstream from Lancaster, you find the Crook O' Lune. At this point on the river there is a 180-degree bend in the River Lune, which turns back on itself, followed by a 90-degree bend that together form the shape of a shepherd's crook. For hundreds of years this spot on the river has been a favourite for relaxing and taking a paddle, and it was also a popular stopping point for artists including J. M. W. Turner.

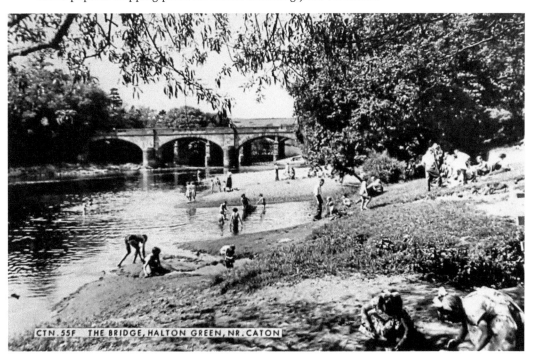

CTN. 55F THE BRIDGE, HALTON GREEN, NR. CATON

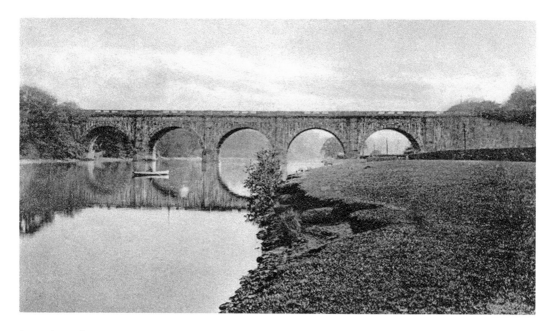

Lune Aqueduct

The Lune Aqueduct carries the Lancaster Canal over the River Lune and was completed in 1797. It was designed by John Rennie and constructed by architect Alexander Stevens. The total cost of the construction was close to £50,000. Toward the end of the construction there was a rush to complete it before the winter and men were sent to work around the clock. This pushed the cost of the project over budget and the lack of additional funds was the reason that the Lancaster Canal was never joined to the main canal network, as there was no money to construct an aqueduct over the River Ribble.

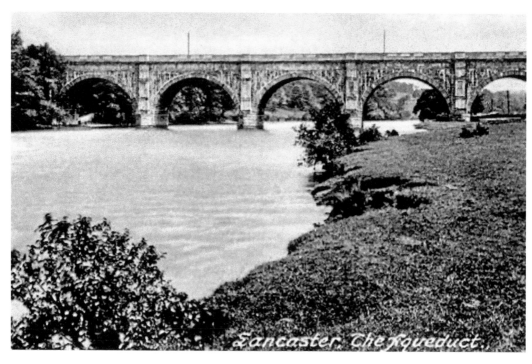

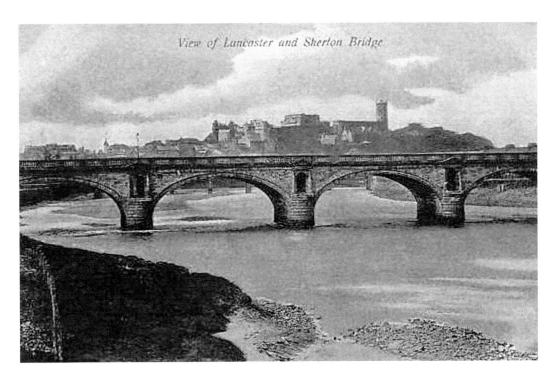

View of Lancaster and Skerton Bridge.

Skerton Bridge

One of the most important bridges connecting Lancaster is Skerton Bridge, which was designed by architect Thomas Harrison, who in 1782 won the first prize in a competition to design the new bridge. It was designed to cross the River Lune and act as a replacement for the old medieval bridge. Finally, after some minor changes, the first stone was laid in June 1783 with the bridge being completed four years later in September 1787 at a cost of £14,000.

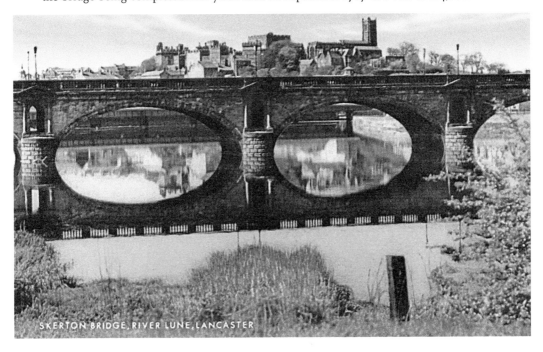

SKERTON BRIDGE, RIVER LUNE, LANCASTER

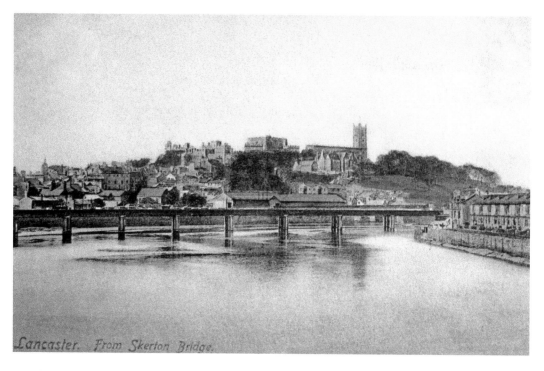

Lancaster. From Skerton Bridge.

Greyhound Bridge

Greyhound Bridge, which is now a major road bridge, was originally constructed out of wooden timbers to carry the Morecambe Harbour & Railway line to the coast in 1848. This was replaced from 1862–64 by a new train bridge built using iron and again replaced in 1911. When the railway line was closed in 1966, the bridge was converted to accommodate road vehicles, reopening in 1972 and serving as the main bridge out of Lancaster towards Morecambe.

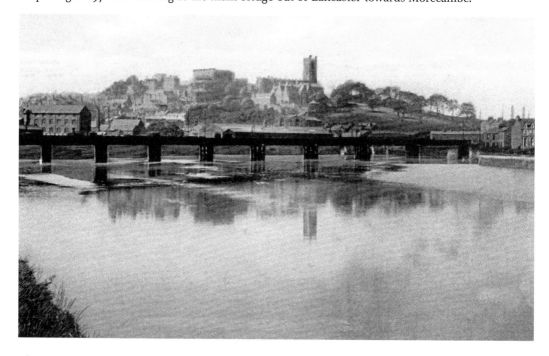

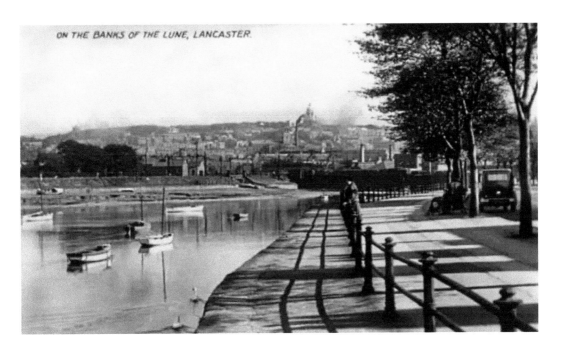

St George's Quay

One of the most important areas of Lancaster dating from the Georgian period is St George's Quay. The area developed at the height of the slave trade and was the commercial hub of Lancaster throughout the late eighteenth century. Between 1750 and 1755 the area along the riverside went from being a barren unused space to a fully functional quayside complete with customs house, warehouses, inns and shipbuilders. At its height, Lancaster was the fourth largest port for the slave trade, behind London, Bristol and Liverpool, and from the records we know that around 29,000 slaves had been transported during this period.

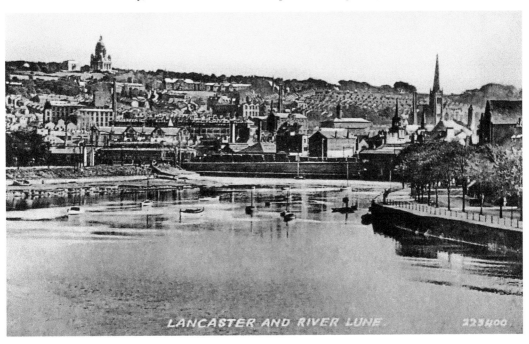

LANCASTER AND RIVER LUNE 223400

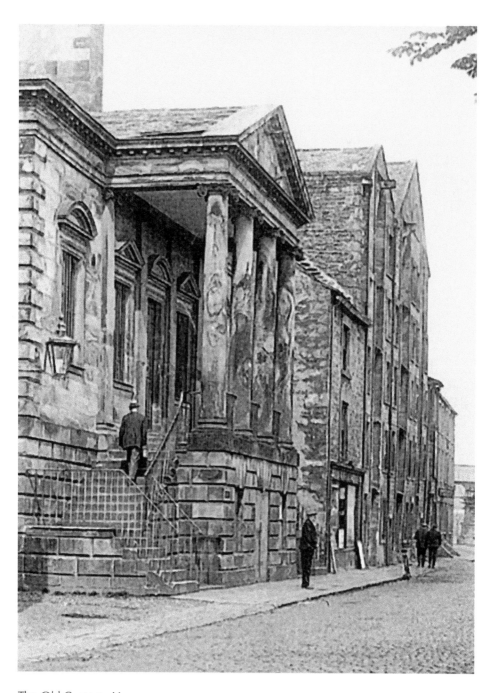

The Old Customs House

The customs house was built in 1764 and designed by Richard Gillow, a member of the Gillow family of furniture makers. From surviving records we know that the customs house was built in fifteen months using local stone quarried near Ellel on the outskirts of Lancaster and the cost of the building was £784 7s and 1/2d. The customs house was home to the customs officer who had an office on the first floor, with the upstairs of the building being used for the day-to-day transactions and payment of taxes, whereas the ground floor housed weighing scales for the goods being brought into the port.

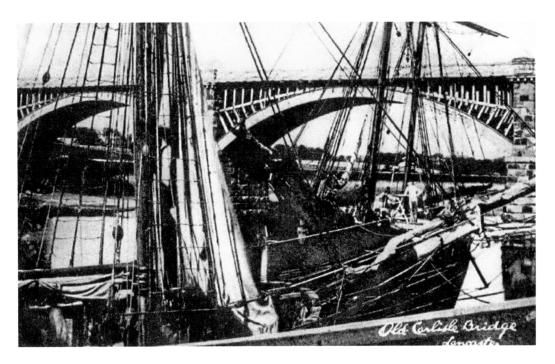

Carlisle Bridge

The final bridge in the town centre is the imposing Carlisle Bridge, which carries the West Coast mainline across the River Lune on its journey northwards. The original bridge was constructed between 1844 and 1846, and opened in 1847. It underwent alterations in 1866 when the timbers used to span the supporting pillars were replaced with iron, with them once again being replaced with concrete and steel in 1962–63.

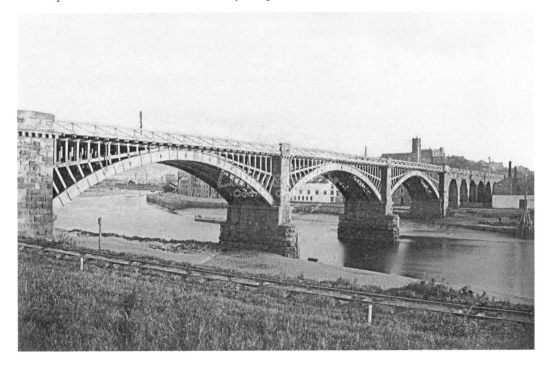

CHAPTER 3
AROUND CASTLE HILL

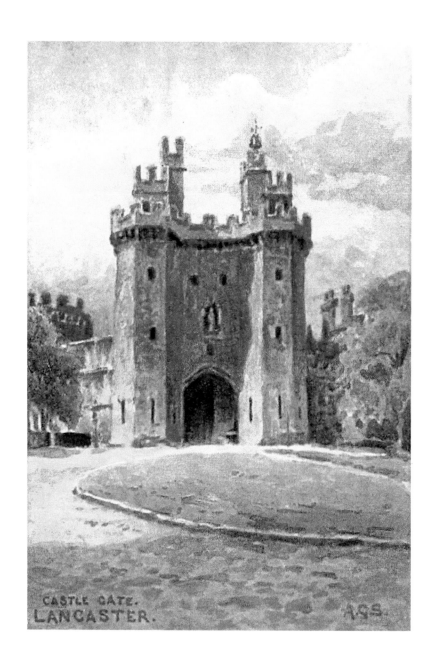

CASTLE GATE.
LANCASTER. A.S.S.

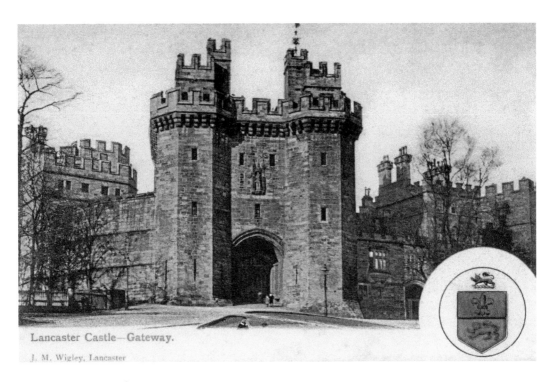

Lancaster Castle—Gateway.

J. M. Wigley, Lancaster

Lancaster Castle

One of the most prominent structures on the Lancaster skyline is the imposing fortress of Lancaster Castle that has stood proudly on Castle Hill for over 900 years. It is the oldest standing structure in Lancaster and has been the site of many important events from the Wars of the Roses to the Pendle Witch Trials. The castle has undergone many alterations and renovations throughout its history and has served as a prison, court and prisoner of war camp.

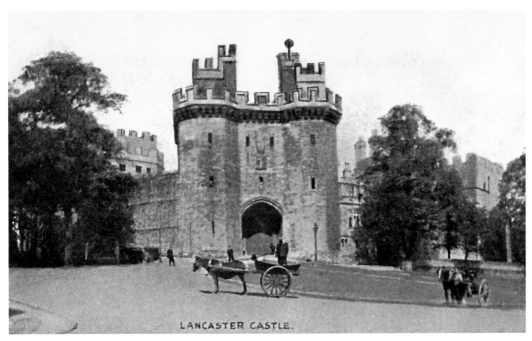

LANCASTER CASTLE.

23

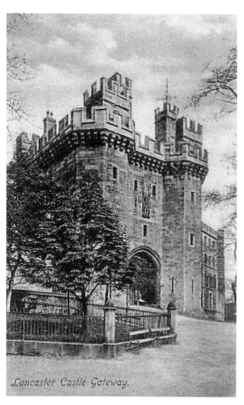

Lancaster Castle Gateway.

John O'Gaunt's Gateway

One of the most notable aspects of Lancaster Castle is the impressive gatehouse, which was constructed shortly after Henry IV came to the throne. Unusually, it is constructed from two semi-octagonal towers around 20 metres high and has a statue of John O'Gaunt standing proudly above the entrance. This gatehouse acts as the main entrance to the castle to this day, complete with portcullis and accessible by the steeply sloping path leading up from the bottom of Castle Hill.

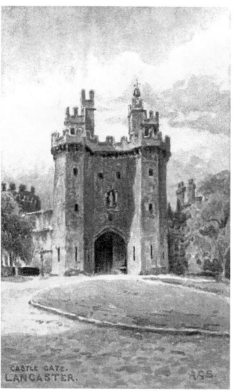

CASTLE GATE.
LANCASTER.

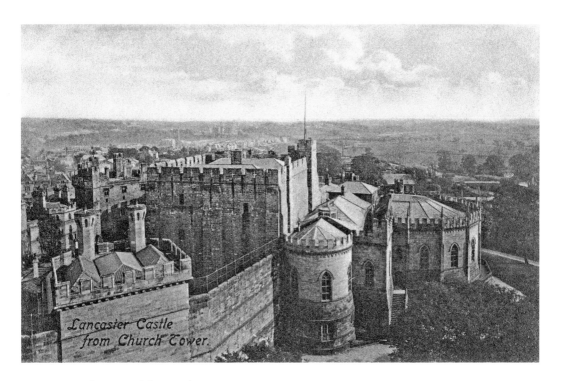

Lancaster Castle from Church Tower.

General Views of the Castle

Over the centuries the castle has undergone several major renovations and alterations, especially during the eighteenth and nineteenth centuries. These images show some aspects of the castle that until fairly recently were unable to be seen by the general public. The interior of the castle, its impressive walls, towers and imposing keep, were rarely seen from the outside due to its usage as a prison.

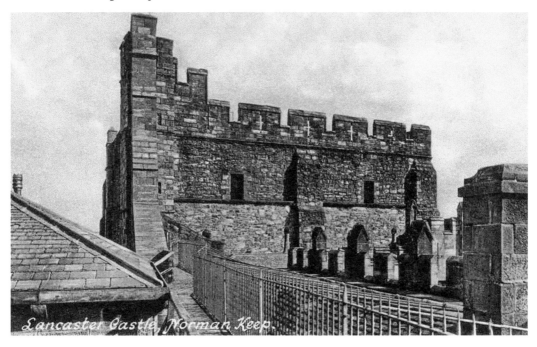

Lancaster Castle, Norman Keep.

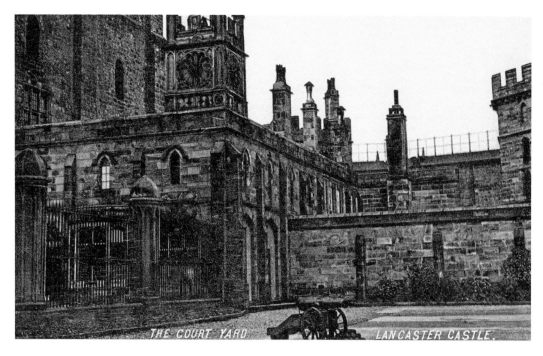

THE COURT YARD LANCASTER CASTLE.

General Views of the Castle II

The last major program of building works at the castle were undertaken by Thomas Harrison at the end of the eighteenth century. He constructed the Keepers House as well as the new female prison. Other constructions included the male prison, two additional floors of accommodation for debtors and an arcade around the south side of the keep to provide shelter from the rain. He incorporated many new ideas of the time into his designs, especially the separation of prisoners both by sex, and by type of crime.

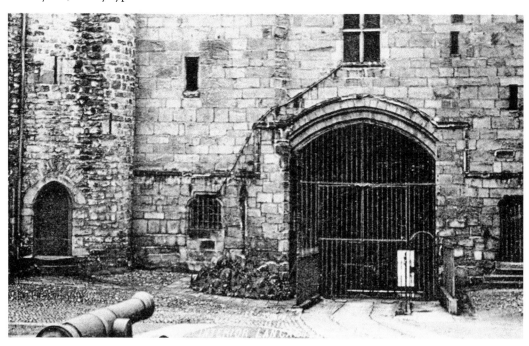

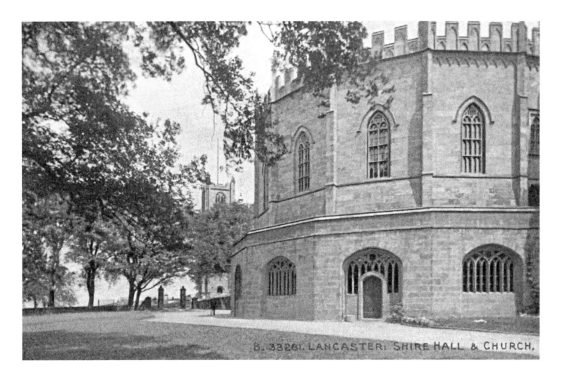

B. 33261. LANCASTER: SHIRE HALL & CHURCH.

The Shire Hall Exterior

In 1796 the medieval hall, which housed the Crown Court, was demolished and plans for a new Crown Court and Shire Hall were created by architect Thomas Harrison. The most impressive of his plans was the Shire Hall, completed in 1798 and designed in an ornate Gothic style, containing elaborate carvings and plasterwork details including the red rose of Lancashire.

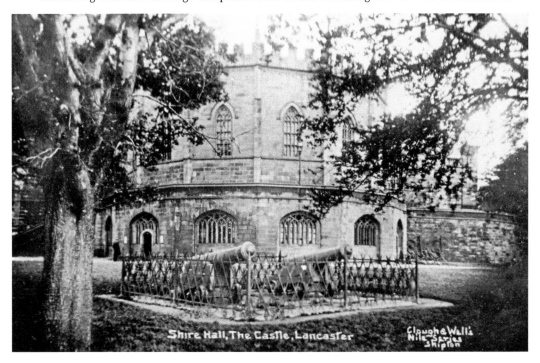

Shire Hall, The Castle, Lancaster

Clough & Wall's
Nile Series
Shipton

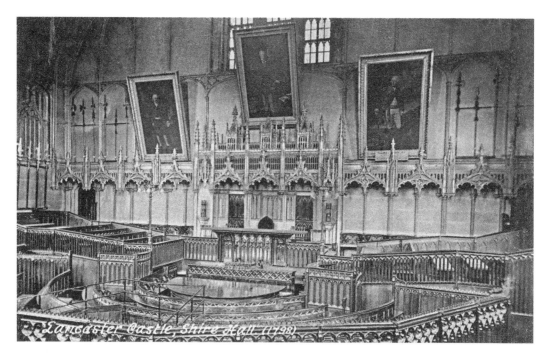

The Shire Hall Interior

Unfortunately, after the completion of the new structures there was a shortage of money, which meant that there was a delay in completing the interior decoration and furnishing. Other details including the window tracery, seating and elaborate canopy over the judge's bench were not designed by Joseph Gandy until 1802. Today one of the most impressive sites in the Shire Hall is the wall of shields that shows the coats of arms of every English monarch since Richard the Lionheart, as well as all the constables of Lancaster Castle and the high sheriffs of Lancashire.

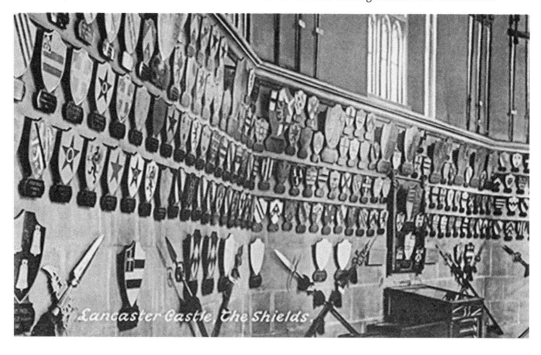

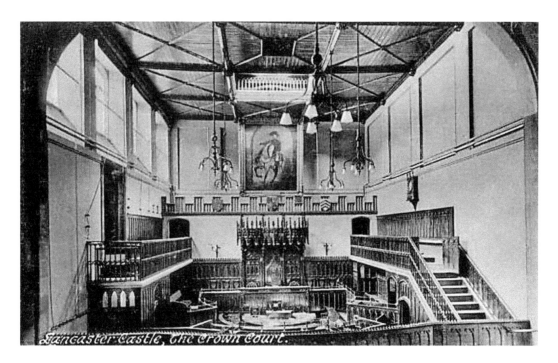

Lancaster Castle, the Crown Court.

Lancaster Castle Interior

One part of the castle that still remains relatively private today are the courtrooms and the cells. The courtrooms are still used for criminal cases, although the old cells are not. Lancaster has a long heritage in relation to criminal cases and used to be a host city for the travelling assize courts that visited yearly. The cells to this day remain relatively untouched, complete with their wooden doors and small windows for light and ventilation.

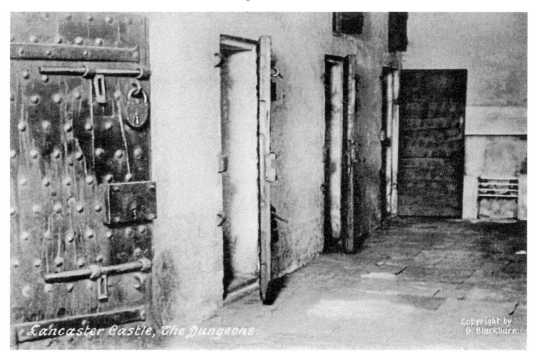

Lancaster Castle, the Dungeons.

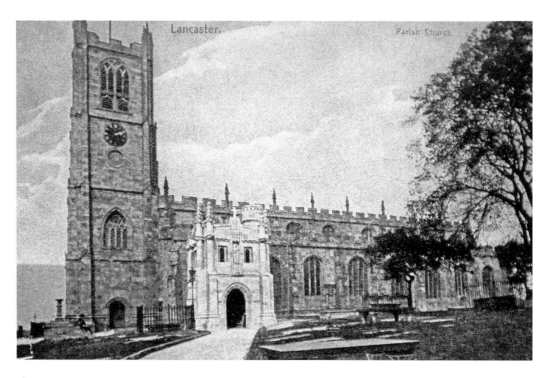

Lancaster Priory

The current church was established in 1094 as a Benedictine priory dedicated to St Mary. The priory was the creation of Roger de Poitou who owned the lordship of the area. By 1430, the priory had become very important within the district and became the official parish church. In 1539 Henry VIII abolished the monastic institution at the priory, ending 445 years of monks living within the church, and in 1541 the priory became part of the diocese of Chester.

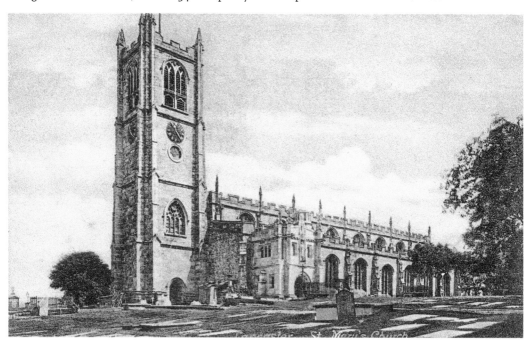

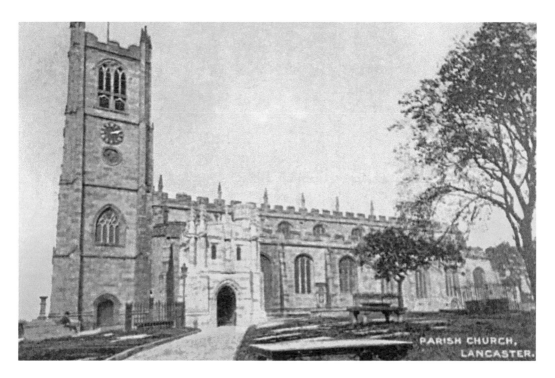

PARISH CHURCH,
LANCASTER.

Lancaster Priory II

In 1743 the steeple was raised by 10 yards so that its bells could be heard more clearly, and at the same time the bells were also recast. Surprisingly only ten years later, in 1753, the tower fell into an awful state of repair and was at risk of collapse. Due to the condition a decision was made to remove the bells to reduce the weight in the tower. Henry Sephton was asked to demolish and rebuild the tower, which was completed in 1759. The tower can still be seen to this day.

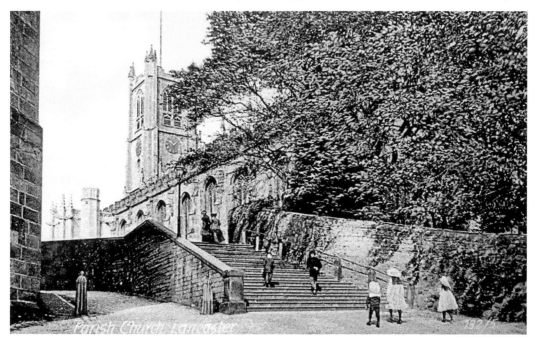

Parish Church, Lancaster

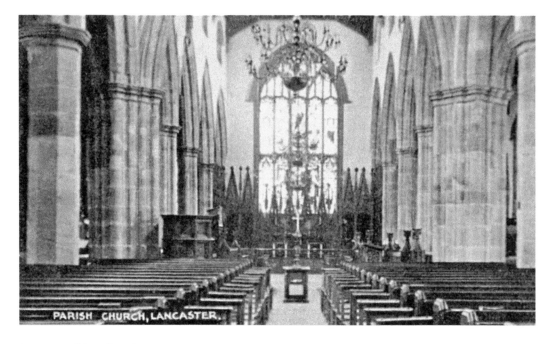

Lancaster Priory Interior

In 1619 the new Jacobean pulpit was erected, on top of which sat a carved bible and crown. Over the years the pulpit was changed and pieces removed and simplified. It took until 1999 to restore and reinstate the original crown and bible. In 1870, local architects Paley & Austin undertook work on the chancel, the same year they presented the church with the eagle lectern that is still used today. Twelve years later they also constructed the vestry and added an organ chamber. The King's Own Regimental Memorial Chapel was constructed in 1903, and in 1912 an investigative excavation was undertaken before restoration works began. The excavation discovered a possible Roman wall beneath the chancel and also a small Saxon doorway in the west wall of the nave.

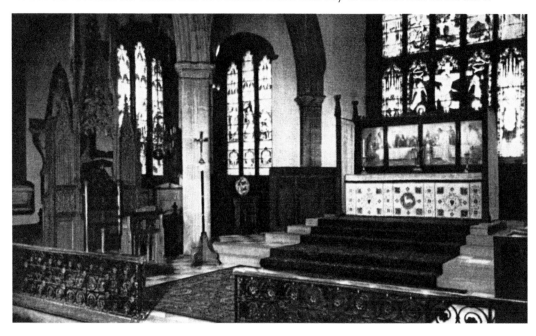

The Storey Institute

The building was designed by local architects Paley, Austin & Paley and was constructed between 1887 and 1891 to commemorate the Golden Jubilee of Queen Victoria. It was paid for by local businessman Thomas Storey and the aim of the institute was to promote science, art and literature, as well as promoting technical teaching. The building housed a library, reading room, laboratory, lecture room and music room, as well as a school of art, picture gallery and accommodation. It was renamed the Storey Institute in 1891 to honour Thomas Storey. It was extended between 1906 and 1908 to commemorate the accession of Edward VII and provided additional teaching space, which almost doubled the size of the building.

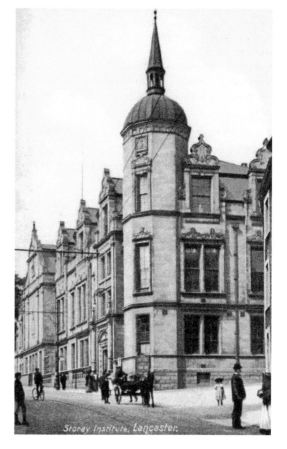

Storey Institute, Lancaster.

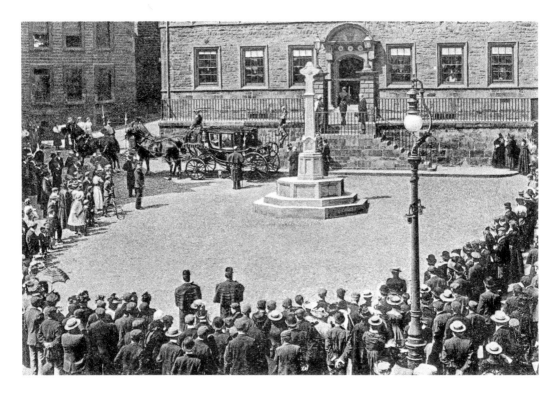

The Judge's Lodgings

The building is the oldest existing town house in Lancaster and dates from around 1625, when the house was owned and redeveloped by Thomas Covell. The building was used as early as 1635 for accommodating visiting judges who were in Lancaster as part of the assize courts. Outside of the building you find the Covell Cross Monument, which was erected in 1903 to commemorate the Coronation of Edward VII, who became king in 1902.

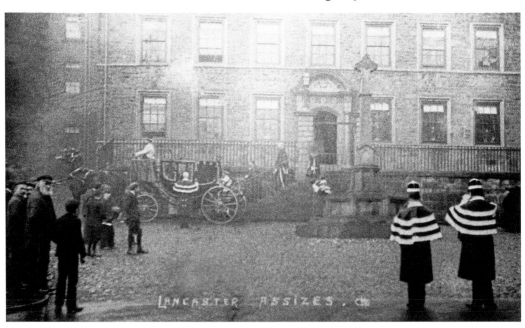

COUNTY HOTEL, LANCASTER.

JOSIAH S. DUCKSBURY
PROPRIETOR

Castle Hill

The location of Castle Hill has not only been an important site for Lancaster's monumental buildings, but has also been an important place for the citizens of the town to live. The area became especially desirable during the Georgian period when the towns wealthy merchants chose to construct their new houses around the perimeter of the castle. These buildings to this day remain some of the finest examples of Georgian architecture that survive in the town.

Castle Park, Lancaster.

2348.

CHAPTER 4
THE CITY CENTRE

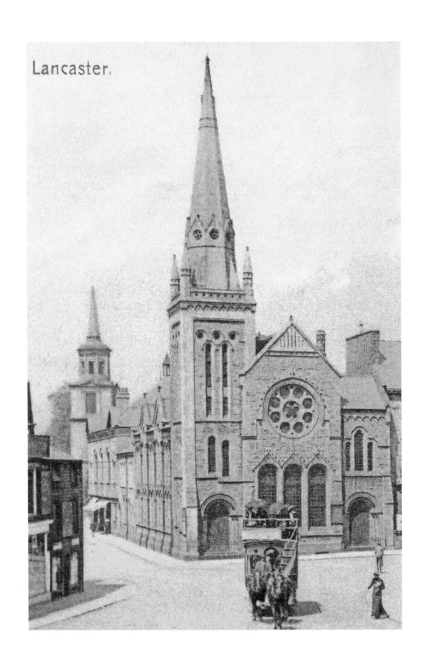

Lancaster.

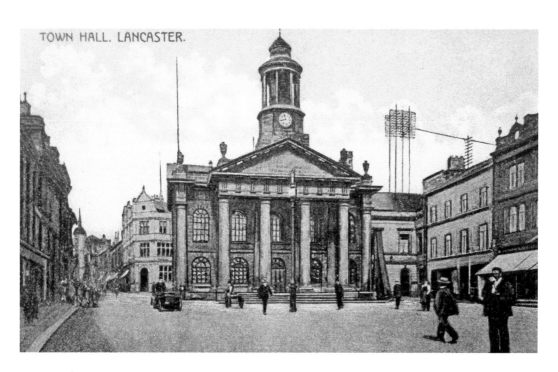

TOWN HALL. LANCASTER.

Market Square

The centre of Lancaster and its layout has not changed all that much from the one set down by the Romans during their occupation of Lancaster. The centre of the city has always been centred on the Market Square, an important hub for commerce and markets since 1193. Even during the Middles Ages as the town began to expand, the market remained relatively untouched and even in the modern day is the biggest open space at the centre of the town. Over the years the square has also been home to police and fire stations and also a bus station.

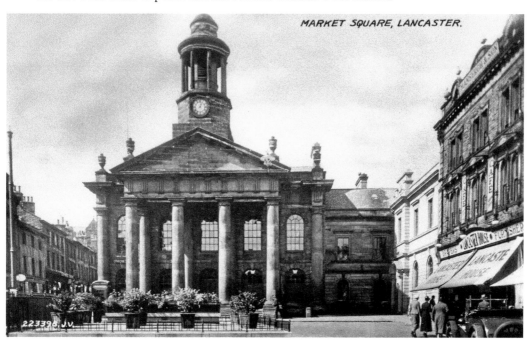

MARKET SQUARE, LANCASTER.

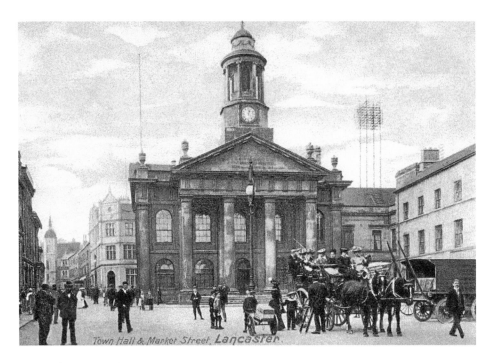

Town Hall & Market Street, Lancaster.

The Old Town Hall

At the heart of Market Square is the Old Town Hall, which was designed by Major Thomas Jarrett and was constructed between 1781 and 1783. The town hall was further modified and extended in 1871 and 1886, but by the beginning of the twentieth century the Lancaster Corporation had outgrown its current home and there was a need for a new town hall. As well as housing the original town hall, the building was also home to the court, Barclays Bank until 1969, and Natwest Bank until 1977.

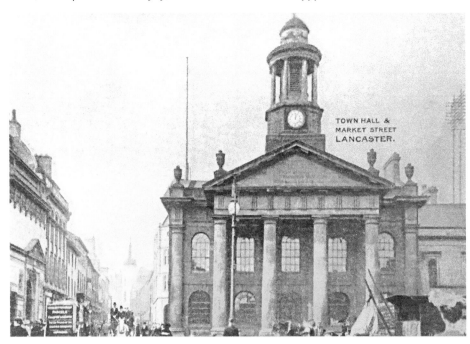

TOWN HALL & MARKET STREET LANCASTER.

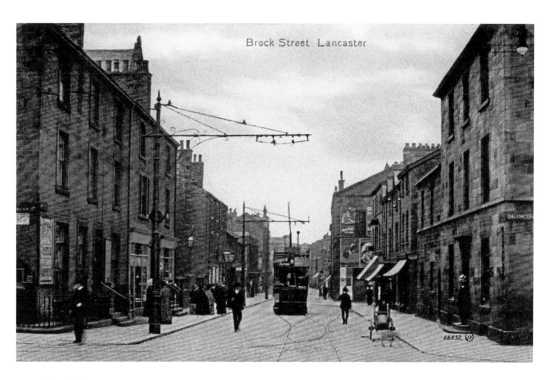

Brock Street

One of the main thoroughfares towards the top of the town is Brock Street, which connects with Common Garden Street at one end and Dalton Square at the other. Over the years the street has undergone many changes; however it was a vital route for the Lancaster tram network during the Victorian Period and allowed the two sides of the town to be connected easily.

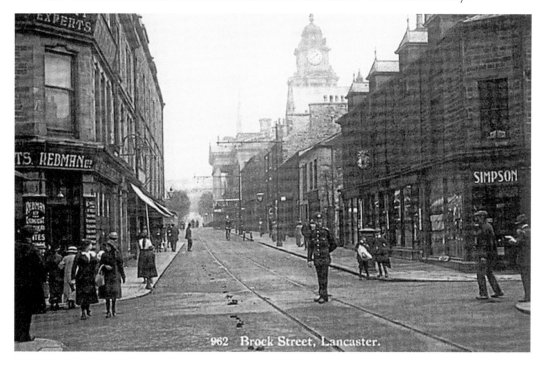

962 Brock Street, Lancaster.

Church Street

During the Middle Ages the street was known as St Marygate and was used as an open market on Lancaster fair days. The street is also home to some notable buildings including the former home of the Lancaster Banking Co. and No. 76, which was owned by the Marton family during the eighteenth century. It is known that Bonnie Prince Charlie stayed there in October and December 1745.

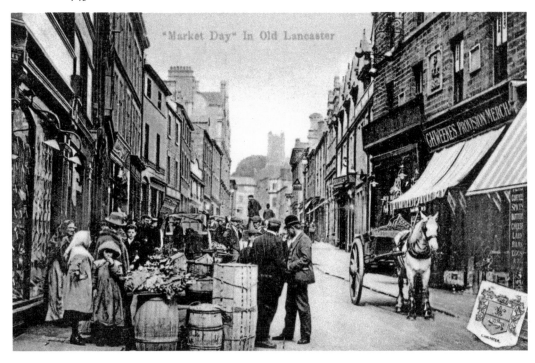

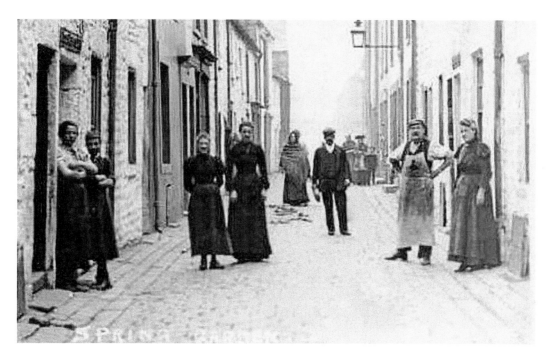

City Centre Streets

Over the past two centuries many of the streets in the centre of Lancaster have been altered or removed. The city centre was once home to a warren of small lanes and yards similar to many British towns at the time. Over the years, through rebuilding and the construction of transport routes many of these have been lost, living on only through surviving photographs and maps from the time.

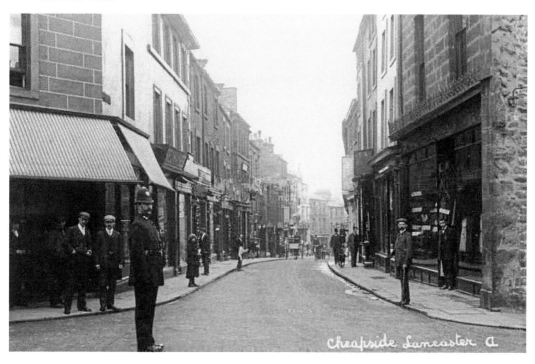

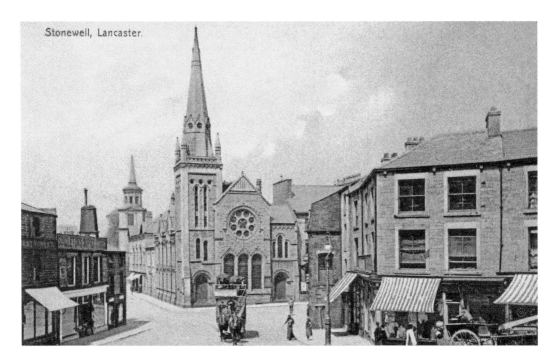

Stonewell, Lancaster.

Stonewell

Stonewell is located at the junction of St Leonardgate, Church Street and Moor Lane. During the nineteenth century the area was known as St Mary's Square. The prominent church was built in 1879. In earlier maps of Lancaster the area is shown as being the location of a pond that was fed from a mill stream and acted as the only sewer in the town. This area has undergone many changes over the years and a number of streets have been demolished to make way for new structures.

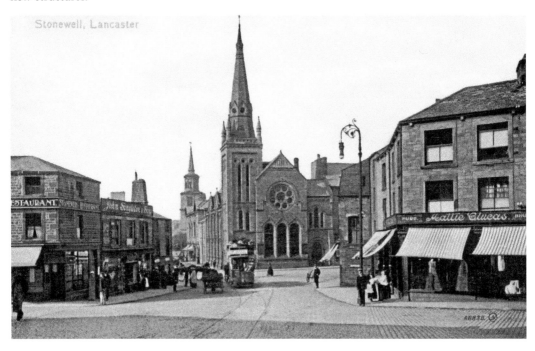

Stonewell, Lancaster

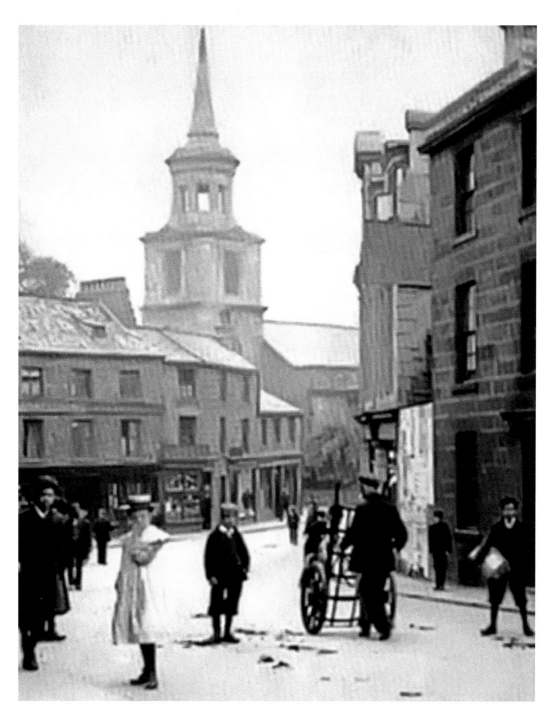

St John's Church

The church was built between 1754–55, possibly by the architect Henry Sephton. A few years later in 1784, local architect Thomas Harrison designed a new tower and spire for the church. Almost 100 years later, in 1874, the south porch was built and in the 1920s a chapel and vestry were added. The interior was restored in 1955 by Sir Albert Richardson and in 1981 the church officially closed.

CHAPTER 5
DALTON SQUARE

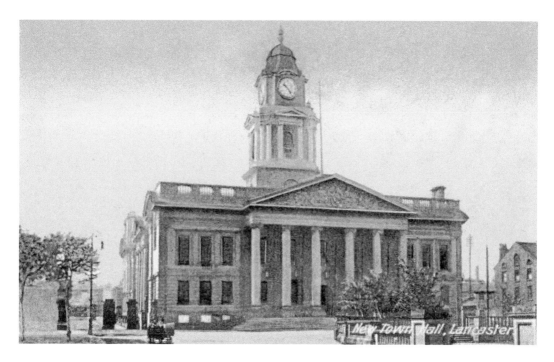

The New Town Hall

In 1904 it was decided to construct a new town hall and plans began to be drawn up. Construction work began in 1906 and was undertaken by Waring & Gillow, and stained-glass windows were created by local company Shrigley & Hunt. It was officially opened by Lord Ashton on 27 December 1909 and housed the council departments in addition to the police station and magistrates' court.

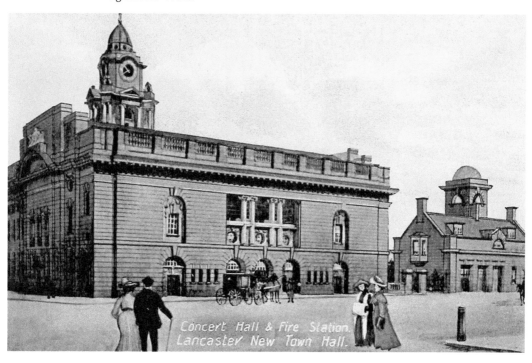

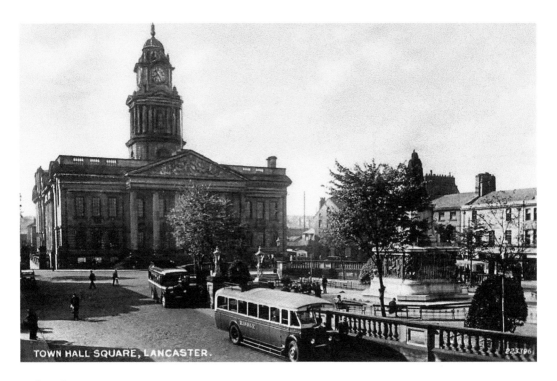

TOWN HALL SQUARE, LANCASTER.

Dalton Square

Dalton Square sits on the site of the original Dominican friary, with the location of the original friary being beneath Sulyard Street. Around 1260 the first friars came to the area and settled on 12 acres of land. The site was sold to Sir Thomas Holcroft during the Dissolution of the Monasteries in 1539, and he constructed a house on the site.

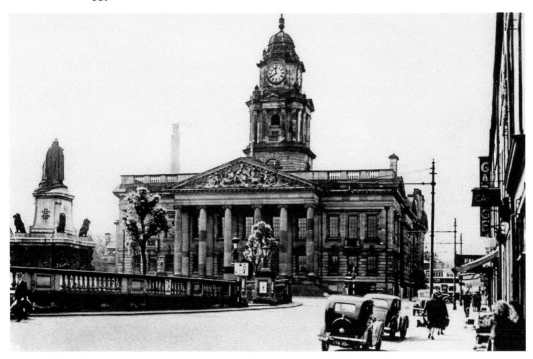

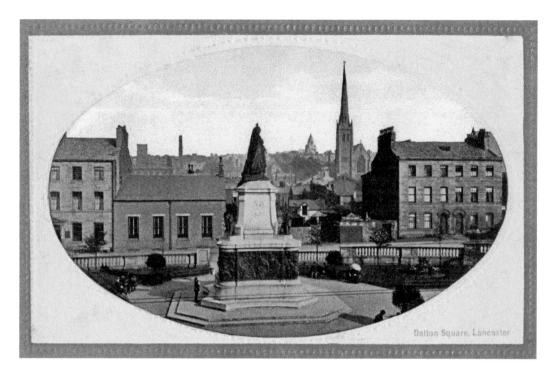

Dalton Square II

In 1784, John Dalton obtained the rights to develop the site; however, due to economic problems, his original design commissioned from Edward Batty was never constructed. During the Edwardian period, the square was once again redesigned to accommodate the new Victoria Monument, and at the same time new surrounding walls were built.

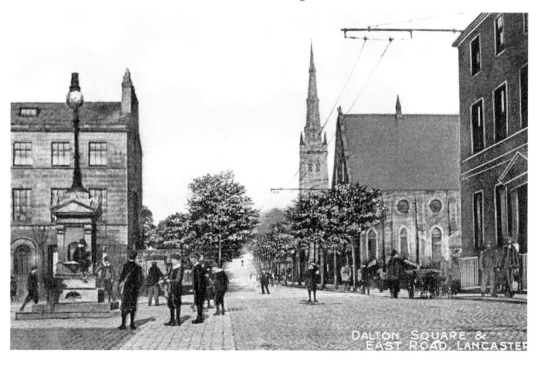

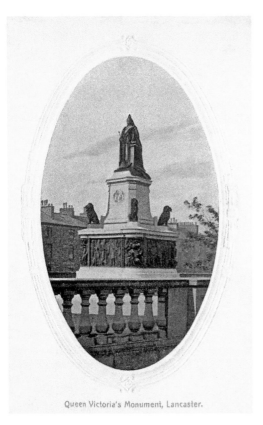

Queen Victoria's Monument, Lancaster.

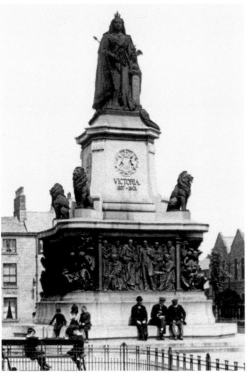

The Victoria Monument

At the heart of Dalton Square stands Lancaster's memorial to Queen Victoria. It was paid for by local businessman Lord Ashton and was designed by sculptor Herbert Hampton. The statue of Victoria had originally been intended for Williamson Park, but it was decided instead to place it in Dalton Square, Lancaster, facing Lancaster Town Hall. It was unveiled in 1906 and prominent Victorians are depicted around the base, including local scientist Richard Owen and businessman Lord Ashton.

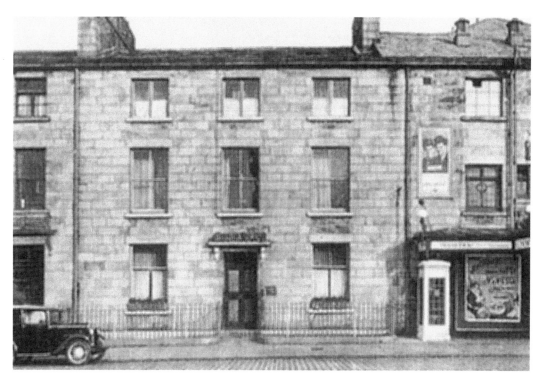

Other Notable Buildings

Dalton Square is also home to several other notable buildings. No. 2 Dalton Square was the home of the infamous Dr Ruxton who murdered his wife and maid during one of the most famous cases of the 1930s. Close by you also find the Palatine Hall, which was originally a Catholic chapel and later became a music hall, cinema and eventually council offices.

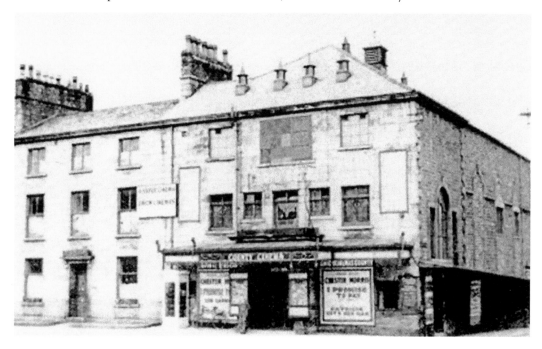

CHAPTER 6
WILLIAMSON PARK

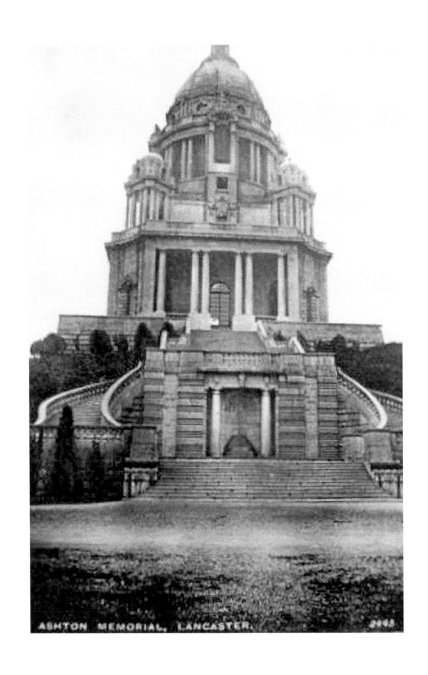

ASHTON MEMORIAL, LANCASTER.

Williamson Park

The park is one of the most important and impressive locations within the town. It was gifted to the town by the Williamson family who were local factory owners and wished to give something back to the town from which they had grown wealthy. The park was founded in the 1870s by James Williamson Snr, who tasked John Maclean to create a plan including impressive landscapes and gardens. Sadly he never saw his vision completed but his dream lived on through his son Lord Ashton who completed the park, donating it to the Lancaster Corporation in 1881 and it formally opening for public use in 1896.

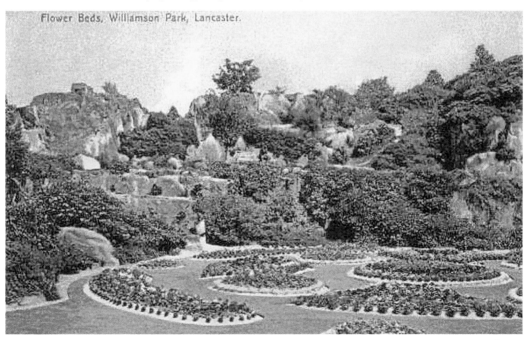

Flower Beds, Williamson Park, Lancaster.

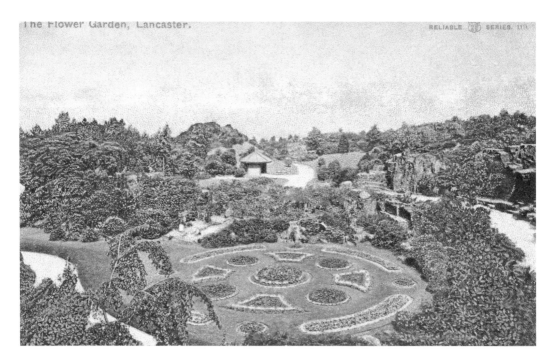

The Gardens

One of the most important aspects of Williamson Park has always been the carefully tended landscapes and garden displays. During the Victorian and Edwardian period the park was renowned for its lavish floral displays of brightly coloured flowers and plants. Other areas of the park were allowed to grow naturally, creating areas of forest and peaceful areas where visitors could wander in seclusion and enjoy the extensive park.

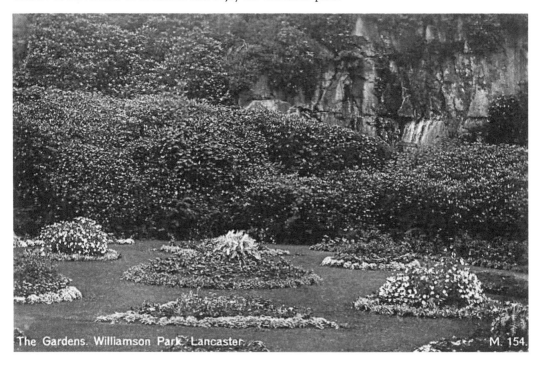

The Gardens. Williamson Park. Lancaster. M. 154.

Ashton Memorial

Within Williamson Park stands the imposing structure of Ashton Memorial, which is one of the largest follies in Britain. The building was originally commissioned in 1907 to be a memorial for his deceased second wife. In 1907 and he hired Sir John Belcher to design the structure using a mix of stone and a copper dome. The building was constructed by local company Waring & Gillow and was officially opened on the 24 October 1909 as the centrepiece of the newly improved Williamson Park.

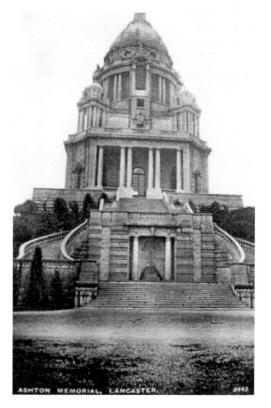

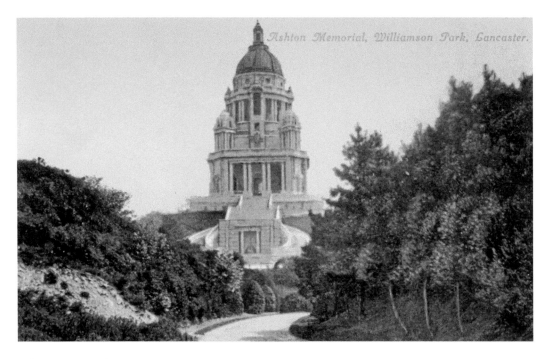

Ashton Memorial, Williamson Park, Lancaster.

Ashton Memorial II

Within a decade of completion the memorial was beginning to suffer significant damage and was in urgent need of repair – rainwater had began to seep into the structure and was affecting the concrete causing it to crack, leading to the steel within the building beginning to rust. Lord Ashton provided additional funding so that the repairs could be undertaken; after his death his wife continued to fund renovations. By 1981 it had become structurally unsafe and was closed. Renovations took place between 1985 and 1987 and the memorial finally reopened in May 1987.

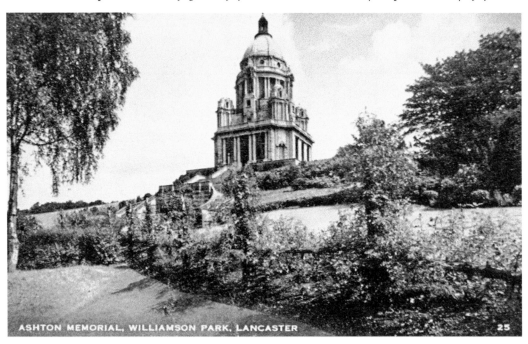

ASHTON MEMORIAL, WILLIAMSON PARK, LANCASTER 25

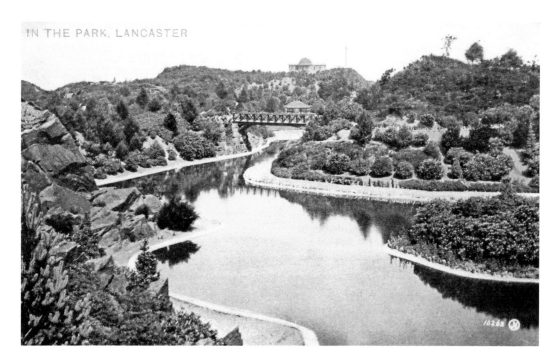

The Lake

At the beginning of the twentieth century Sir John Belcher was commissioned to improve and create additions to the park for the benefit of the local residents. One of the most notable features of the park had always been the impressive lake close to the entrance, complete with a bridge crossing it. He set about creating a new fountain to sit by the side of the ornamental lake and spray a stream of water high into the air, a popular attraction with visiting children.

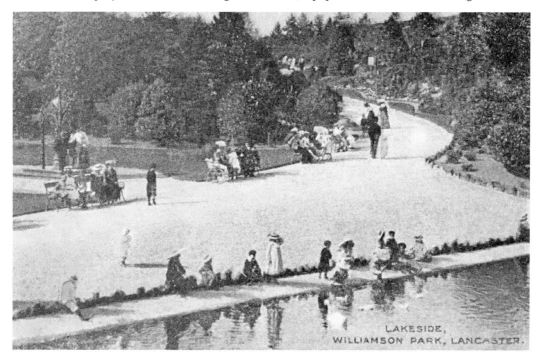

LAKESIDE,
WILLIAMSON PARK, LANCASTER.

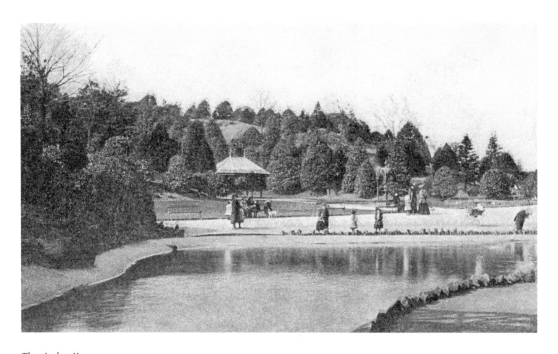

The Lake II

Over the years the lake and the area surrounding the lake underwent some minor additions and changes. The lake was a popular resting point for park visitors and it was a common site on a sunny day to see Victorian ladies taking a rest and talking to one another by the side of it. In 1999 the grounds underwent a major refurbishment and the lake, as well as the fountain and waterfall, were fully renovated.

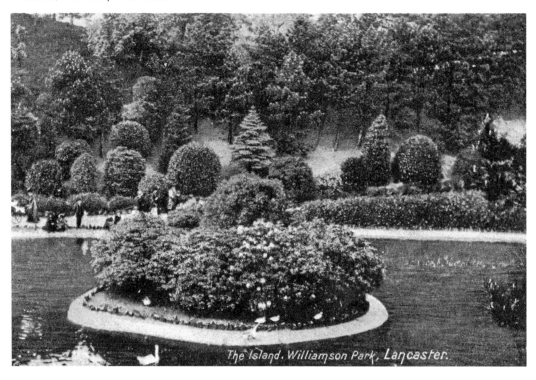

The Island. Williamson Park, Lancaster.

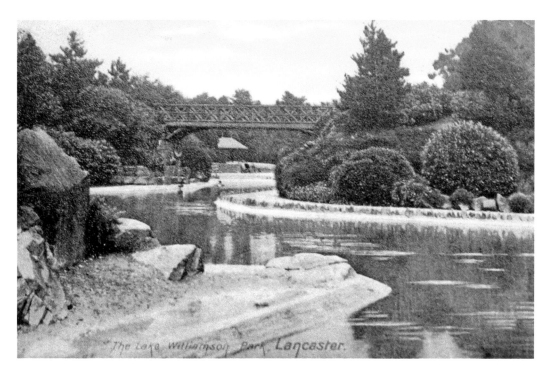

The Lake, Williamson Park, Lancaster.

The Old Bridge

In addition to the great ornamental lake at the heart of the park, a series of paths and trails were created throughout it. One of these routes was designed to cross directly over the lake, and in order to do this a simple wooden structure was erected, allowing visitors to explore the park fully. The early bridge created a great vantage point for viewing the lake and other grounds on a sunny day.

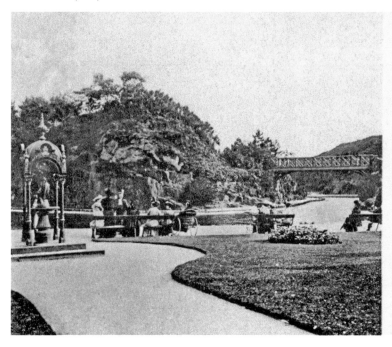

Fountain and Lake,
Williamson Park,
Lancaster.

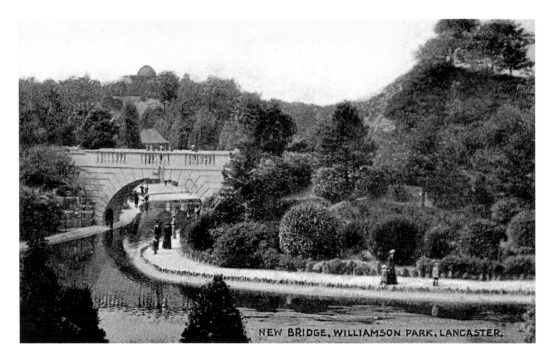

NEW BRIDGE, WILLIAMSON PARK, LANCASTER.

The New Bridge

As the park gained a reputation and various renovations and additions were created, it was decided to rebuild the original wooden bridge in a more suitable and classic style using stone. The new bridge was more imposing than its predecessor but blended in more suitably with its surroundings. To this day the new bridge is a stopping point for visitors taking pictures of the park, with the Ashton Memorial in the background.

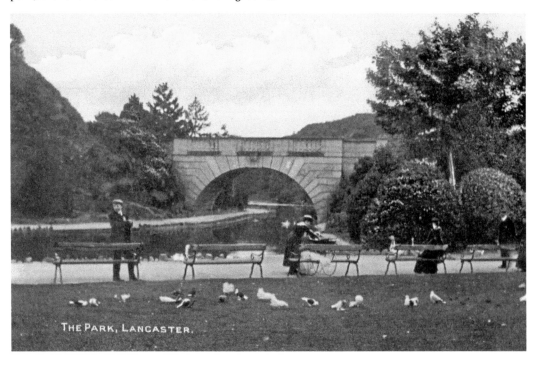

THE PARK, LANCASTER.

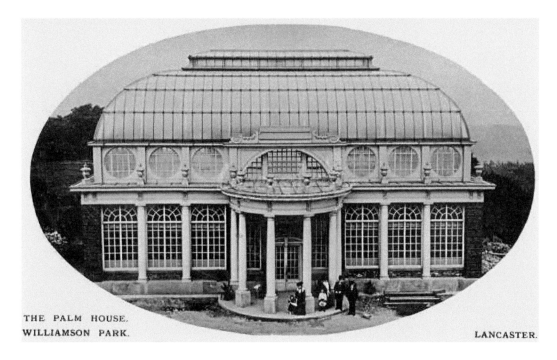

THE PALM HOUSE.
WILLIAMSON PARK. LANCASTER.

The Palm House

As part of his new scheme of park additions, he chose a site close to the Ashton Memorial, and Lord Ashton asked Sir John Belcher to create an impressive glass and metal building that was to house exotic and unusual plants gathered from around the world. In 1942 there was a fire that damaged the building but it was rebuilt and by the 1980s had become known as the Butterfly House.

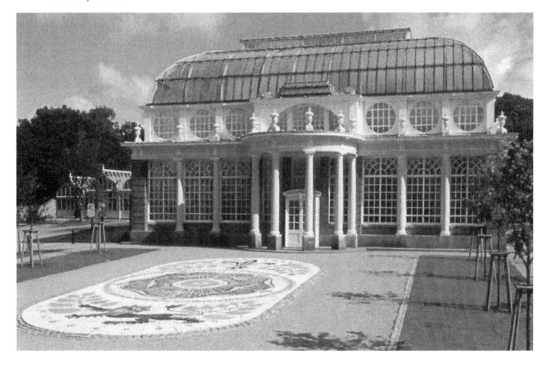

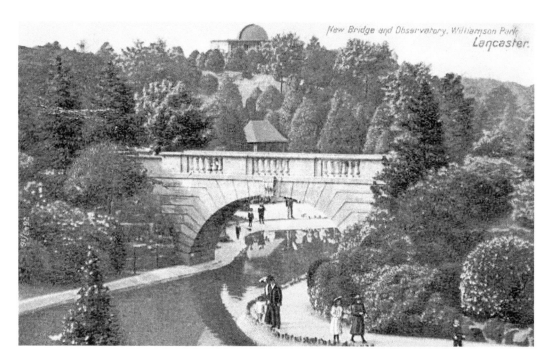

The Greg Observatory

One of the lost structures of Williamson Park is the observatory. The equipment was bought by John Greg and was gifted to the town by his son Albert in 1882. The Lancaster Corporation built the observatory, which opened on the 27 July 1892. It continued to be used until 1939 when problems began to arise, and during the Second World War it fell into a poor state. By 1944 it was closed and abandoned, eventually being demolished in the 1960s.

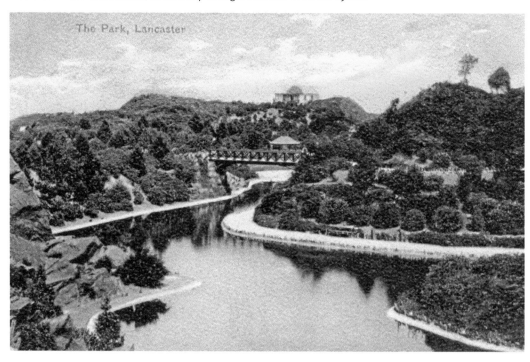

CHAPTER 7

NOTABLE SITES AND BUILDINGS

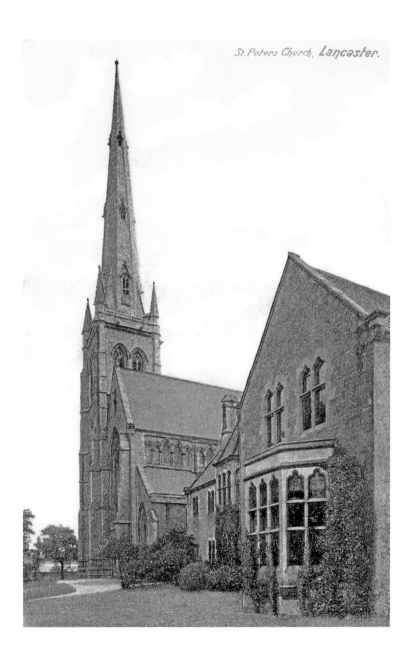

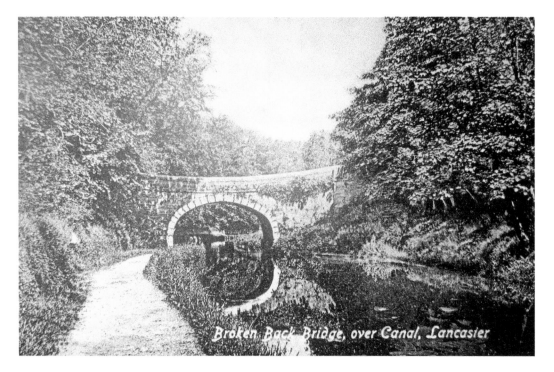

Broken Back Bridge, over Canal, Lancaster

Lancaster Canal

Lancaster Canal was originally planned to run from Westhoughton in Lancashire to Kendal; however, the section around the crossing of the River Ribble was never completed, with parts of the southern end leased to the Leeds & Liverpool Canal. The route was first surveyed in 1772 by Robert Whitworth and was resurveyed in 1791 by John Longbotham, Robert Dickinson and Richard Beck. A final survey was carried out the same year by engineer John Rennie.

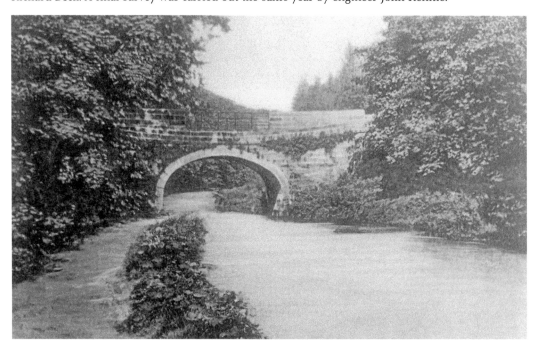

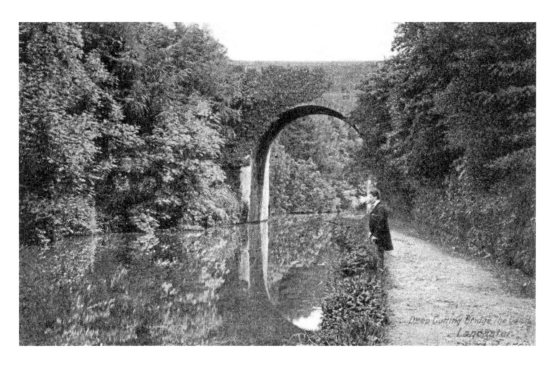

Deep Cutting Bridge The Canal Lancaster

Lancaster Canal II

In 1792 the promoters sought an Act of Parliament that created the Company of Proprietors of the Lancaster Canal Navigation. John Rennie was officially appointed as engineer in July 1792 and work started almost immediately on the level ground from Preston to Tewitfield. By 1797 the aqueduct over the River Lune had opened and boats were able to travel from Preston to Tewitfield. In 1813, work began on the canal north from Tewitfield to Kendal and was completed in 1819. Construction of the Glasson Dock branch began in 1819 and opened in 1826.

Lancaster, View on the Canal

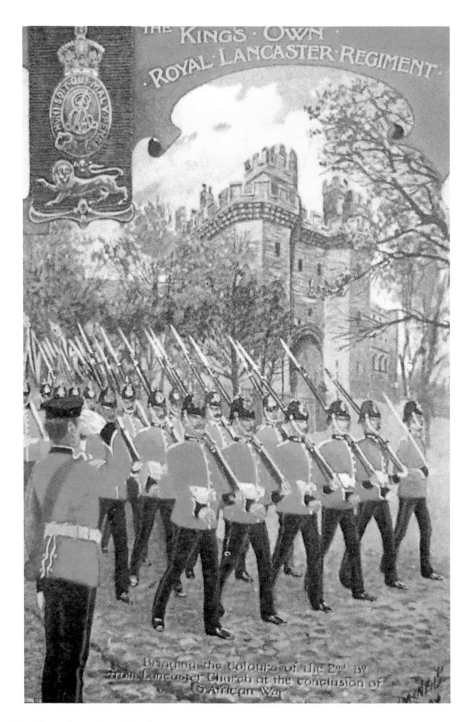

Bringing the Colours of the 2nd Bn from Lancaster Church at the conclusion of S African War

The King's Own Royal Regiment

For hundreds of years Lancaster was the home of the famous King's Own Royal Regiment that was active from 1680–1959. During this period they were involved in many of the most significant campaigns in British history, from the Battle of Waterloo and the Crimean War through to the Boer War and both world wars. In 1959 the regiment was merged with the Border Regiment to form the King's Own Royal Border Regiment.

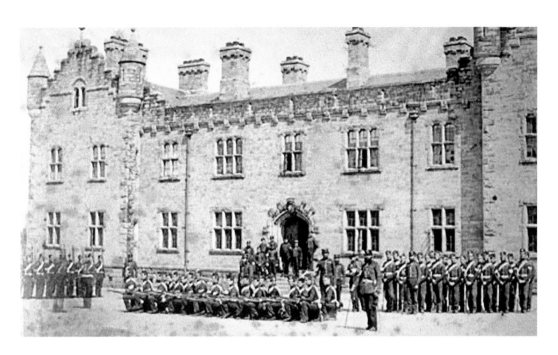

Regimental Barracks

In 1856, a new barracks was constructed for the 1st Royal Lancashire Militia, known as Springfield Barracks. However, within a few years they moved to a new, larger site where the Bowerham Barracks was built. The new barracks provided stables, an armoury, stores, guardroom and hospital as well as accommodation for officers, sergeants, their wives, and two barrack blocks for the recruits. On 20 April 1880 a party of thirty men of the King's Own were the first to occupy the barracks. The main function of the Bowerham Barracks was to provide recruits with their basic training, which continued until the 1950s.

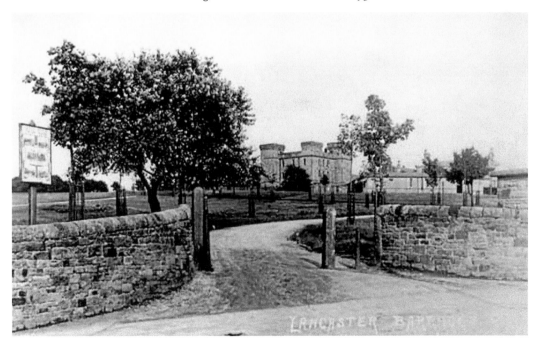

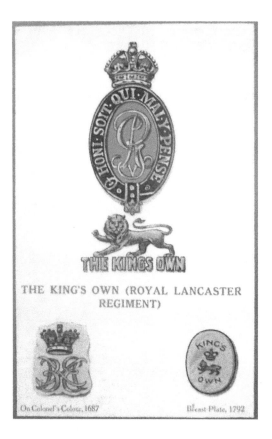

THE KING'S OWN (ROYAL LANCASTER
REGIMENT)

On Colonel's Colour, 1687 Breast Plate, 1792

Regimental Emblem

The regiment gained a somewhat popular reputation for their victories and successful campaigns. In order to promote the organisation to a wider group and also to interest children, a series of postcards were created depicting the regiment in uniform marching past local landmarks. In addition to this they also publicised the regiment and its history through the use of their emblem.

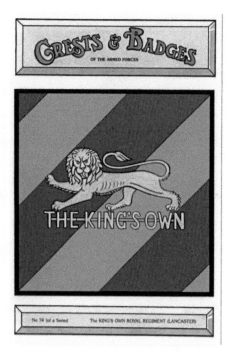

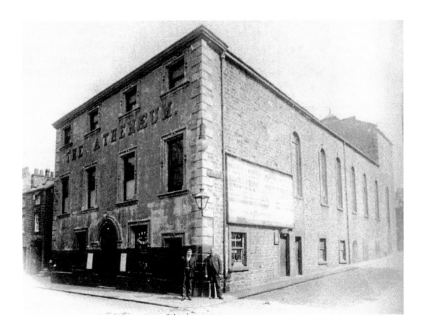

The Grand Theatre

The Grand Theatre is the third oldest in Britain. Construction of the theatre began in 1781 and it was opened a year later by the actor Joseph Austin and Charles Edward Whitlock, who managed a several theatres in the north of England. It was originally known as 'The Theatre, Lancaster'. During the 1830s, the theatre was used less for performances and instead used as a meeting place for the Temperance Society. Edmund Sharpe purchased the theatre in 1843 and undertook alterations, reopening it in 1849 as a music hall. The theatre was closed in 1882 and it reopened in May 1884 as the 'Athenaeum Theatre'. In 1897, the theatre was modified to include a new stage by architect Frank Matcham. The theatre was badly damaged by fire in 1908 but reopened the same year, with a new interior, as 'The Grand Theatre'.

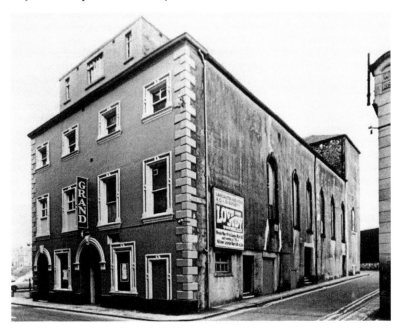

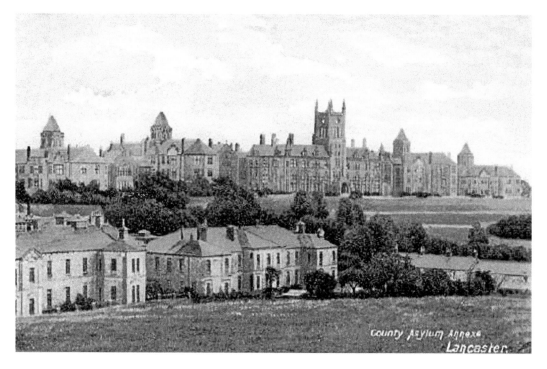

The County Asylum

Lancaster Moor Hospital, also formerly known as the 'Lancaster County Lunatic Asylum and Lancaster County Mental Hospital', was constructed in 1816 and designed by Thomas Standen. An additional chapel, designed by local architect Paley, was built in 1866, and another additional building, known as 'The Annexe', opened in 1883, designed by Arnold Kershaw. The hospital was renowned for pioneering the humane treatment of the mentally ill and eventually closed in 2000.

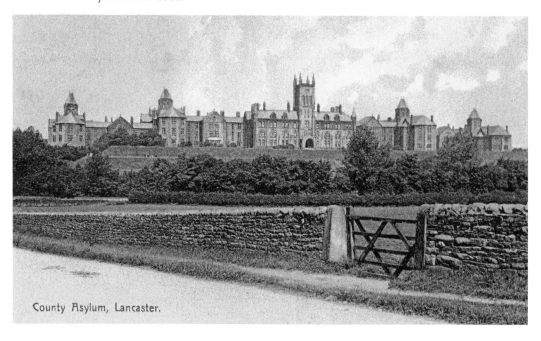

County Asylum, Lancaster.

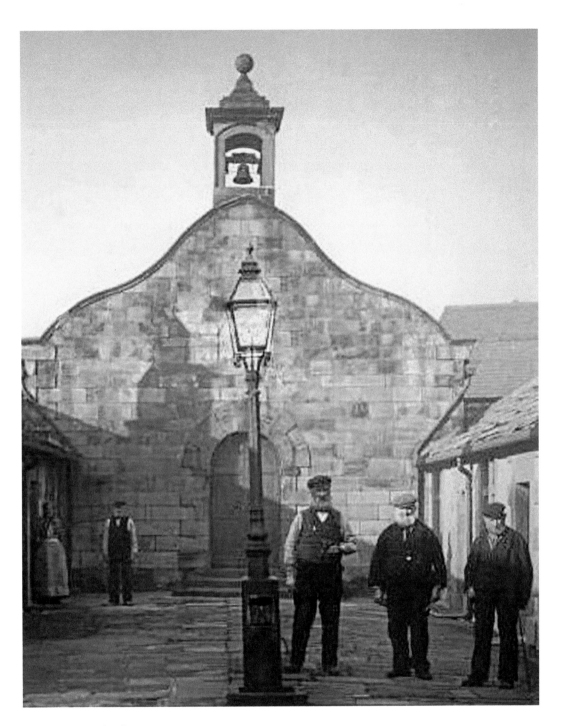

Penny's Almshouses

The almshouses came about through the generous bequest of William Penny, who left in his will a sum of money to enable the construction of almshouses for the 'poor indigent men and women within the town of Lancaster'. In 1720 the houses were constructed, made up of two rows of six almshouses opposite each other, with a chapel at the west end, an arched entrance gateway at the east end and a central courtyard.

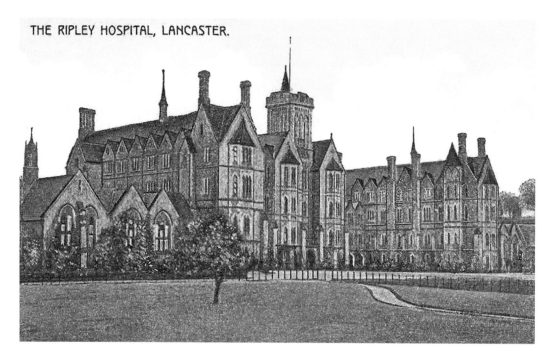

Ripley Hospital

It was founded by Julia Ripley, wife of Thomas Ripley who was local merchant. Upon his death in 1852 he left a large amount of money in trust to establish the Ripley Hospital to cater for fatherless children. The hospital officially opened in 1864. The hospital continued to be used until the beginning of the Second World War when it was requisitioned by the Army, with pupils moving to Capernwray Hall. After the war the government requisitioned Ripley for another three years for use as a training college. The hospital officially closed in 1946 and reopened as a boys' school in 1956.

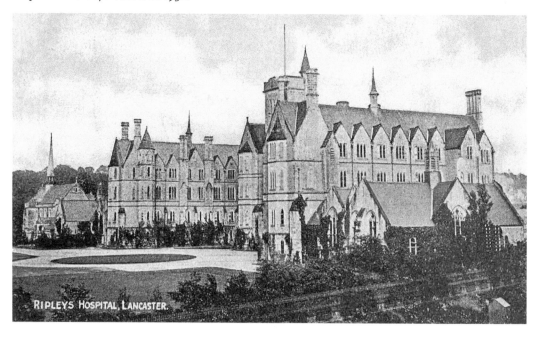

RIPLEYS HOSPITAL, LANCASTER.

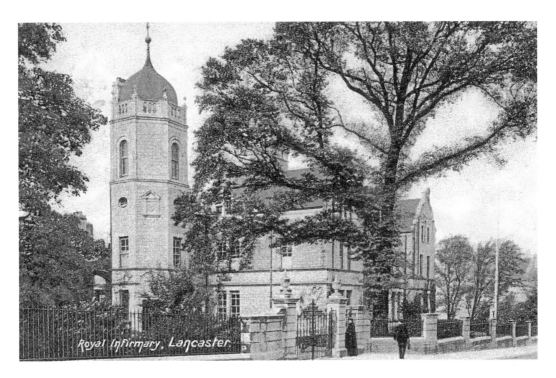

Royal Infirmary

The Royal Infirmary opened in 1896, but its history can be traced back to 1781 when a dispensary was opened on Castle Hill, as well as a later fever hospital that was established in 1815. Both of these health institutions eventually merged and were located on Thurnham Street between 1833 and 1896. The original infirmary building on the current hospital site was designed by local architects Paley & Austin and sits on the site of Springfield Hall. The original building can still be seen to this day by anyone coming into the city centre from the top of Lancaster.

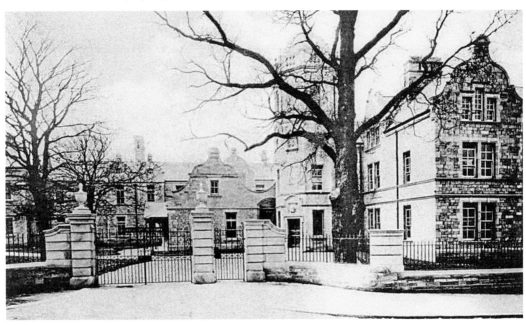

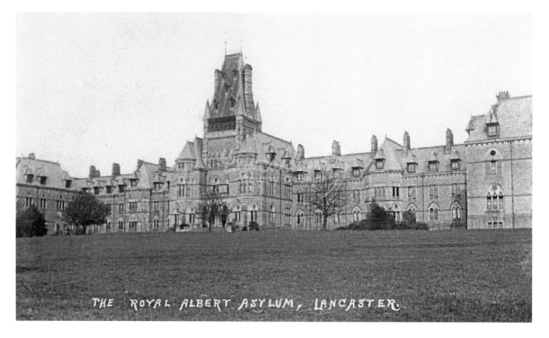

THE ROYAL ALBERT ASYLUM, LANCASTER.

Royal Albert Hospital

The hospital was built in 1868, and in 1870 the first patients arrived. The building was designed by local architect Paley and was originally known as the 'Royal Albert Asylum for Idiots and Imbeciles of the Seven Northern Counties'. The later Winmarleigh Recreation Hall was built at the rear of the hospital and also designed by Paley, Austin & Paley. In 1884, the hospital was renamed the 'Royal Albert Asylum for the Care, Education and Training of Idiots, Imbeciles and Weak-Minded Children and Young Persons of the Northern Counties'. The hospital was once again expanded with the construction of the Ashton Wing between 1898 and 1901, designed by Austin & Paley. In 1948 the hospital became part of the NHS and changed its name to the 'Royal Albert Hospital'. The hospital closed in 1996.

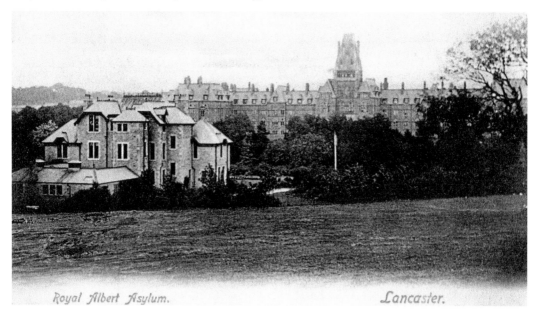

Royal Albert Asylum. Lancaster.

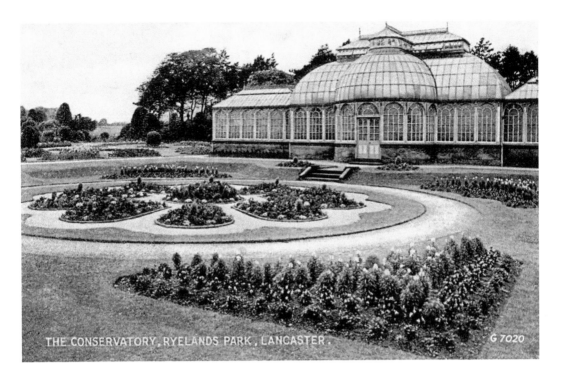

THE CONSERVATORY, RYELANDS PARK, LANCASTER. G 7020

Ryelands Park

The house and grounds were originally built for Jonathan Dunn, mayor of Lancaster around 1836. In 1874 the estate was bought by Lord Ashton, who asked local architects Paley & Austin to undertake various improvements on the estate, which also included the extension of Ryelands House in 1883. The estate grounds were well known for their ornate gardens and conservatory.

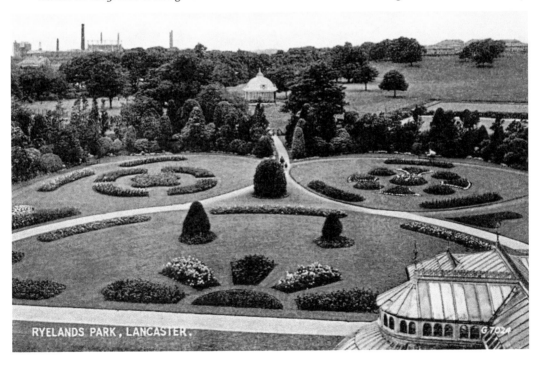

RYELANDS PARK, LANCASTER. G 7024

73

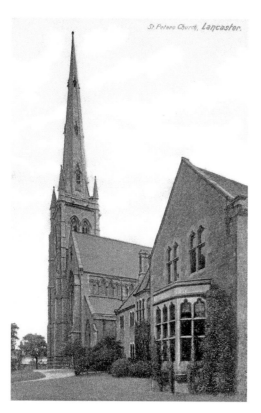

St Peters Church, *Lancaster.*

St Peter's Church

The first Catholic church in the town began with the laying of the foundation stone for the Lancaster Catholic Mission in Dalton Square on 13 March 1798, opening in 1799. However, within a few years there was need for a larger church and land for this was purchased. The new church was designed by the local architect Paley and the foundation stone was laid on the 29 April 1857. The church opened on the 4 October 1859 and was consecrated by Dr Alexander Goss, the bishop of Liverpool.

ST JOSEPH.

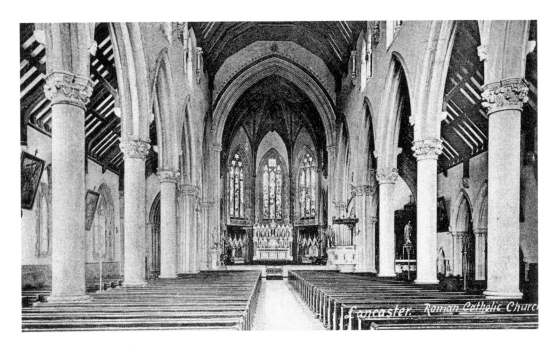

St Peter's Church II

The church and other buildings cost a total of £15,000, of which £2,000 was bequeathed by Thomas Coulston. Over the next few years new additions and alterations were made to the church by Paley, Austin & Paley including the addition of a font in 1860, an organ gallery in 1888, chancel stalls in 1899 and a new baptistery in 1901.

The golden jubilee of the church was celebrated in 1909 and a number of alterations were made under the direction of Giles Gilbert Scott, including a new altar, flooring and replacing the pine benches with oak pews. In 1924 the diocese of Lancaster was created and the church was elevated to the status of cathedral.

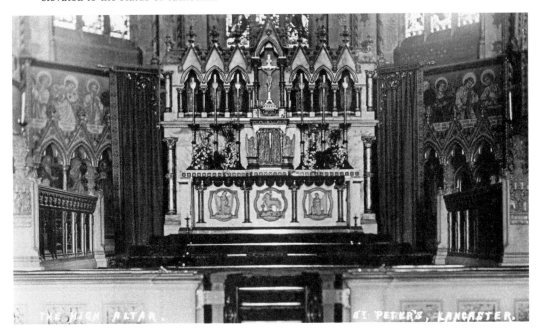

CHAPTER 8
LUNE VALLEY VILLAGES

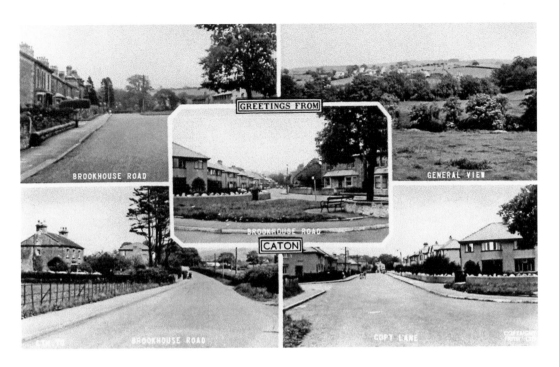

Caton

The village of Caton was originally founded during the Roman occupation. The village as we know it today came about in the late eighteenth century with the construction of several mills in Town End. Low Mill, used for cotton weaving, was constructed by Thomas Hodgson in 1783 and sits on the site of an earlier thirteenth-century corn mill. The mill was powered by a mill race from Artle Beck at Gresgarth, later being replaced by steam power in 1819.

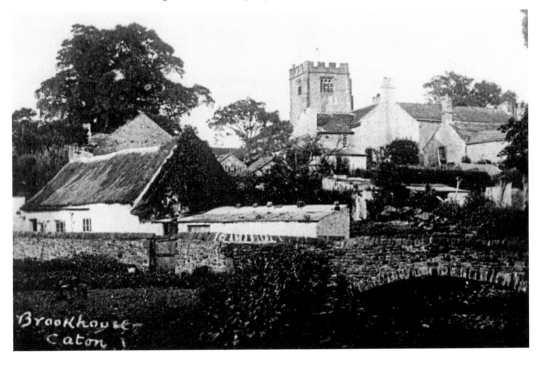

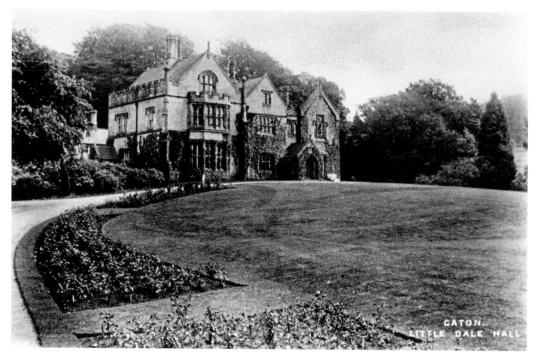

Caton II

During the nineteenth century the village had began to expand and several more mills had been constructed. The village during this period was home to two cotton mills, two silk mills and a flax mill. Most of these mills continued to operate into the twentieth century, with Low Mill and Willow Mill eventually closing during the 1970s.

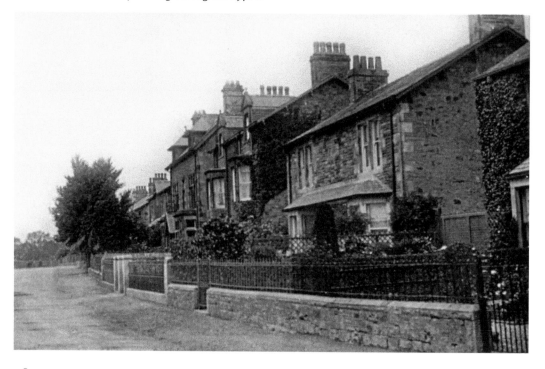

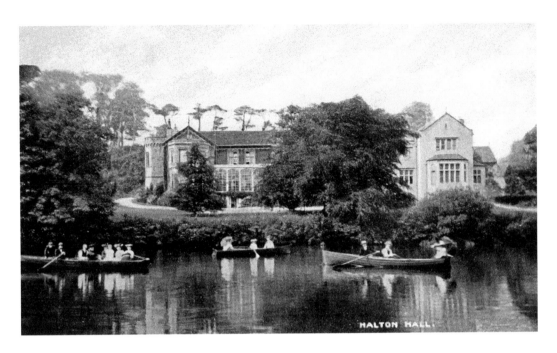

Halton

The village of Halton has a long and interesting past. Halton was originally the centre of an important Anglo-Saxon manor held by Earl Tostig, brother of King Harold. It was originally home to Halton Castle, which was constructed on the site in the late eleventh century. By the twelfth century Roger de Poitou, who held title to the lands after the Norman Conquest, made Lancaster the site of a new castle. Halton Castle was abandoned and to this day only earthworks now remain.

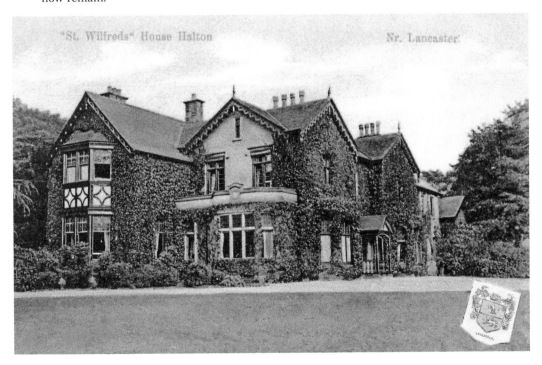

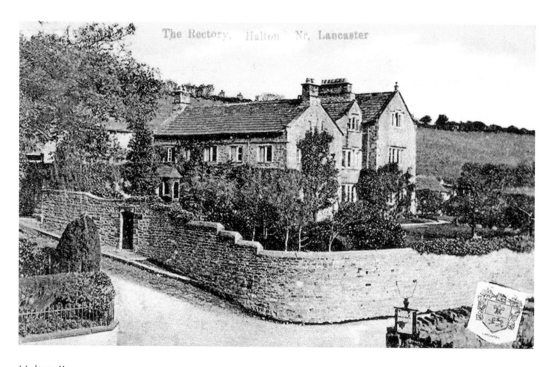

Halton II

Halton today is home to number of seventeenth- and eighteenth-century buildings. During the nineteenth century textile mills were constructed along the side of the River Lune and used water power to operate the machinery. The village was also served by the 'little' North Western Railway and Halton Railway Station was constructed on the opposite side of the River Lune, accessible via a narrow toll bridge. The station was eventually closed in 1966.

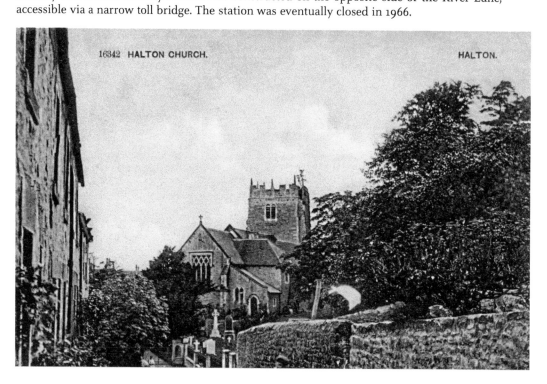

16342 HALTON CHURCH. HALTON.

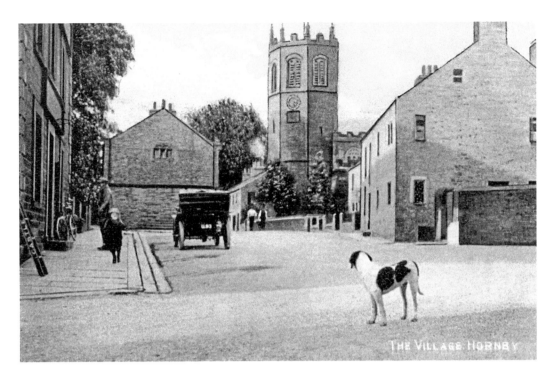

Hornby

The village of Hornby is situated near to where the River Wenning joins the River Lune. In the centre of the village is St Margaret's Church with its unusual octagonal tower. The village is also home to the earthwork remains of Castle Stede, a motte-and-bailey castle dating from the eleventh or twelfth century. The village is arranged around a central main street and is home to a couple of old pubs and the famous Hornby Castle.

Hornby Village

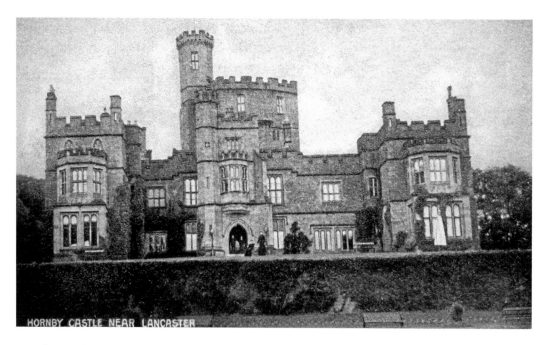

Hornby Castle

Hornby Castle sits at the centre of the village and it is arguably the most recognisable site in the village. It was constructed during the thirteenth century to replace Castle Stede, which was located on the site. The oldest part of the current castle is the tower, which dates from the sixteenth century; the rest of the castle was erected during the eighteenth and nineteenth century. Hornby Castle and its grounds are currently private, with twice-yearly open weekends for the gardens.

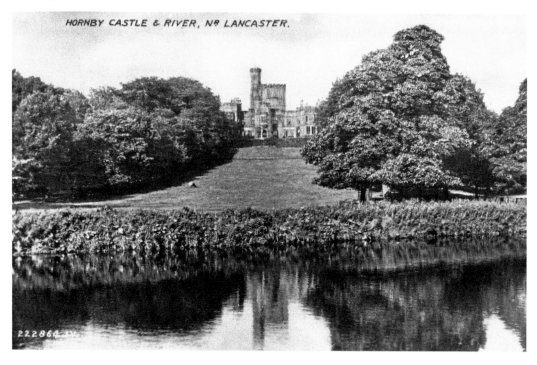

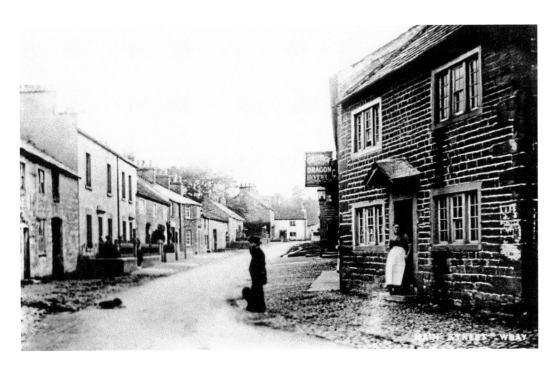

Wray

The village of Wray is located in the Lune Valley close to the River Roeburn. The village has a long history dating from the Middle Ages. The village was once served by the 'little' North Western Railway and had its own station, which opened in 1849 and closed six months later. In recent times the village is remembered for two reasons. On 8 August 1967, the River Roeburn flooded, resulting in the devastation of houses, bridges and death of livestock. Since 1995, the village has also become famous for hosting the annual Scarecrow Festival.

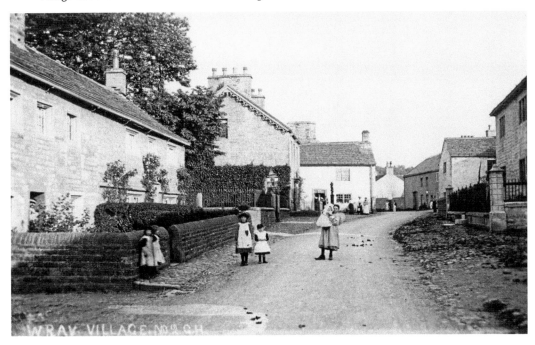

CHAPTER 9
LUNE ESTUARY VILLAGES

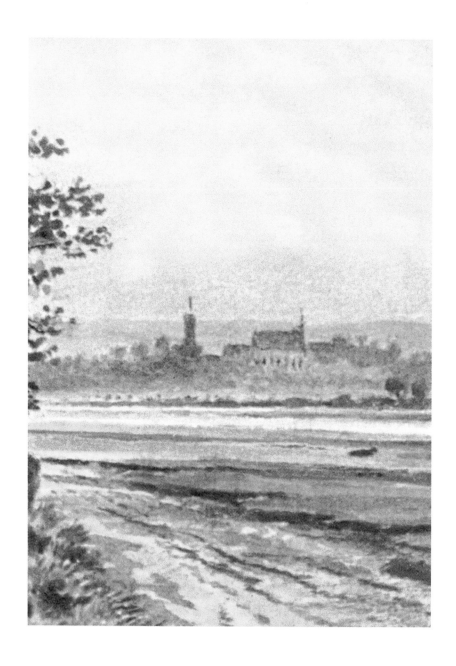

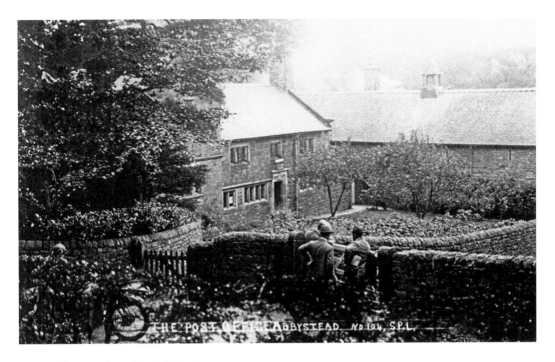

Abbeystead and Dolphinholme

The hamlet of Abbeystead and small village of Dolphinholme are located on the edge of the Forest of Bowland and have a long history dating back to the Middle Ages. Abbeystead is best known as being the home of Cawthorne's Endowed School, founded 1674, as well as Abbeystead House, constructed in 1886 for the 4th Earl of Sefton. Dolphinholme was the home of Lancaster merchant Thomas Hinde, who was involved in the slave trade and built a mill in Lower Dolphinholme in 1795.

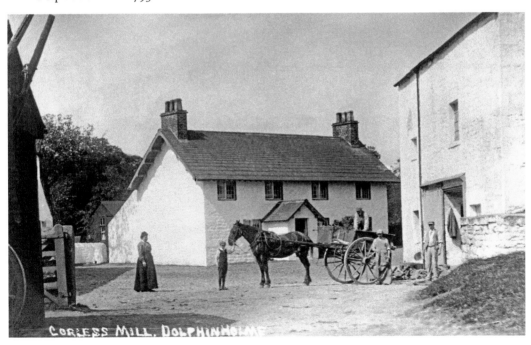

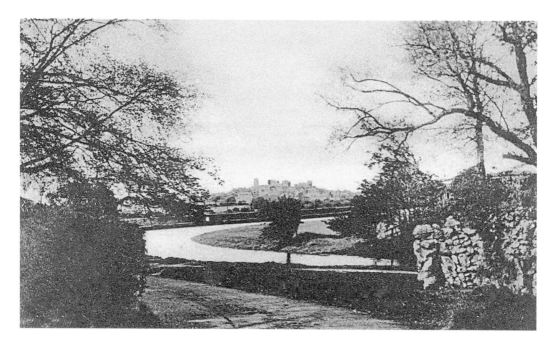

Aldcliffe and Oxcliffe

The villages of Aldcliffe and Oxcliffe lie along the edges of the River Lune on opposite banks in an area of marshes. Aldcliffe has a history that predates the Norman Conquest and the lands around the hamlet came under the control of various religious entities over the centuries until the Dissolution by Henry VIII. Oxcliffe, or Heaton-with-Oxcliffe as it is also known, comprises of the villages of Heaton, Oxcliffe Hill, plus the area around Salt Ayre. It is most famous for being the location of the Golden Ball Inn, a place known locally as Snatchems and where local tales say people were press-ganged from during the height of Lancaster's port.

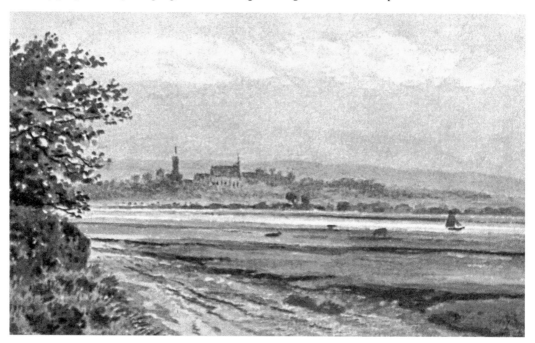

Bay Horse

The small hamlet of Bay Horse can be found on the edge of the Forest of Bowland. The village itself has a few buildings and a pub serving locals and travellers. The village is surrounded by farms, which are the main source of employment in the area. The village itself has not changed all that much and is home to a small number of residents. The Lancaster Canal travels through the village and there was once a train station serving the village, which closed during the 1960s due to low numbers.

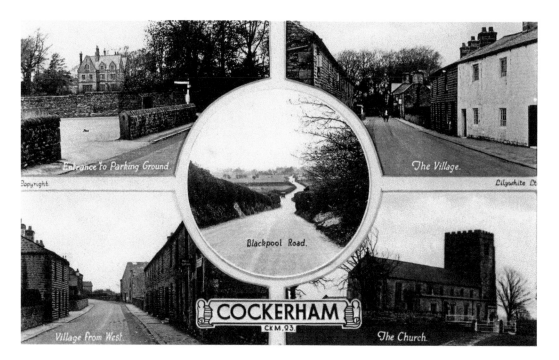

Entrance to Parking Ground.

The Village.

Blackpool Road.

COCKERHAM
CKM.23.

Village from West.

The Church.

Cockerham

The village of Cockerham is located a few miles outside of Lancaster and is one of the main villages that travellers pass through while travelling to Blackpool on the coastal road route. The village has a history dating back to at least the Middle Ages and has always had connections to the land and farming, which still form an important part of the community and employment in the modern day.

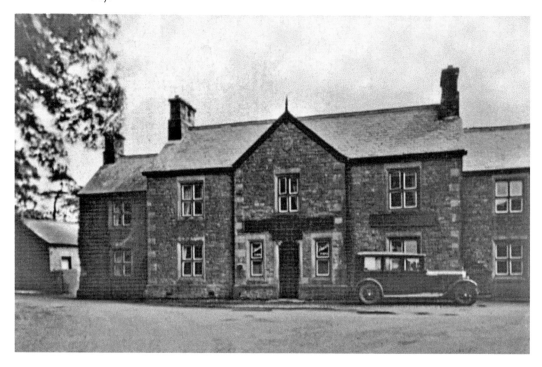

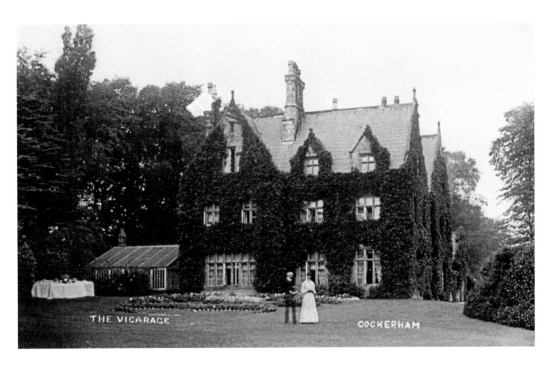

THE VICARAGE COCKERHAM

Cockerham II

The village and some of the surrounding farms can trace their roots back to Viking times, and their names, such as Lathwaite Farm, come from the Norse language. Records have survived from the medieval period including details of rent, services and tenants, which give us a closer look at how the village was managed. The original parish church was originally located in the middle of the village but was rebuilt on higher ground due to issues with frequent flooding.

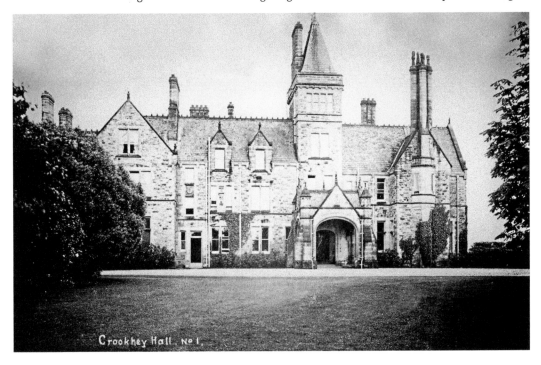

Crookhey Hall. No 1.

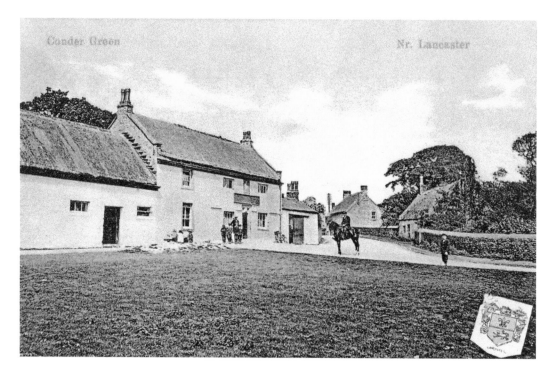

Conder Green

The village of Conder Green is located close to the village of Glasson. There are few buildings in Conder Green, most famously are the Stork Inn, a pub serving travellers for hundreds of years, and the imposing structure of the Conder Green Mill.

The mill was built around 1740 and was purchased by the Canal Co. in 1824. The mill was in a state of disrepair and was sold to the Western Railway Co., who rebuilt it in 1826.

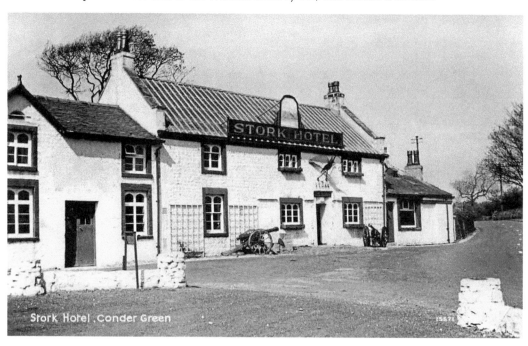

Stork Hotel, Conder Green

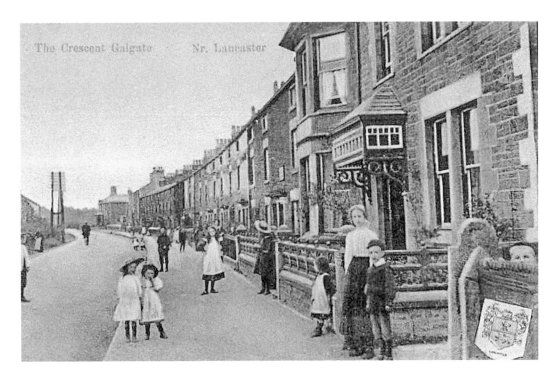

Galgate

The village of Galgate is one of the main villages that travellers pass through on the outskirts of Lancaster. It has been an important route in the area for hundreds of years. During the nineteenth century many industries were founded in the village, and it became known for its silk manufacturing. The remains of one of the factories can still be seen today.

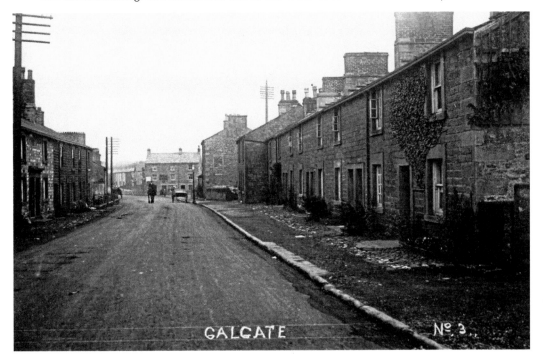

GALGATE Nº 3

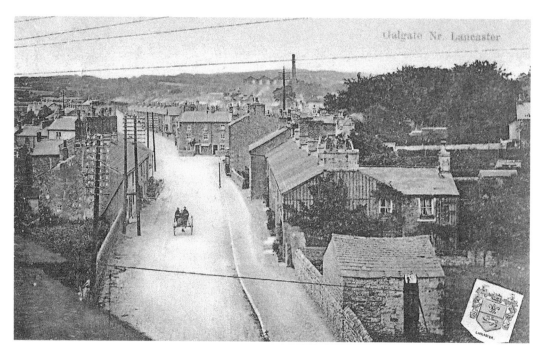

Galgate II

The vital West Coast mainline stretch from Preston to Lancaster passes though the village over a viaduct that serves as the main entrance to the current village. Until 1939 the village was connected to the railway network by Galgate Station. The village is also served by the Lancaster Canal and is home to a small marina used to house narrowboats.

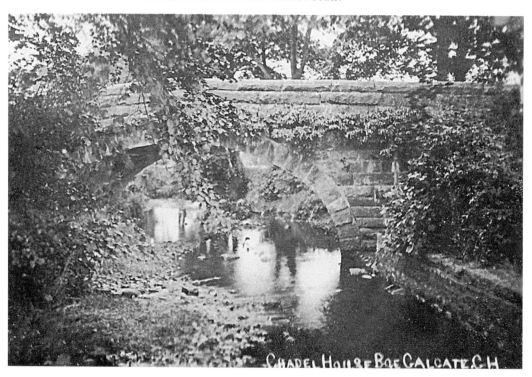

CHAPEL HOUSE BGE GALGATE C.H.

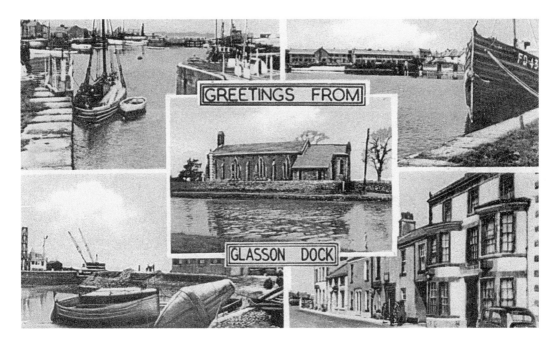

Glasson Dock

Glasson Dock is located at the mouth of the Lune Estuary on the site of a small farming and fishing community, known as Old Glasson and Brows-Saltcote. In 1779, the Port of Lancaster Commission decided to build a dock at Glasson. By 1782, a pier had been constructed; however, shortly after its construction the west wall began to bulge. In August 1782 the commissioners asked engineer Thomas Morris to solve the problem and design a new dock. He produced his plans in November 1783, which involved rebuilding the wall and the construction of another short pier from the opposite bank of the river, so that gates could be fitted between the two. The dock opened in March 1787 and could hold up to twenty-five merchant ships.

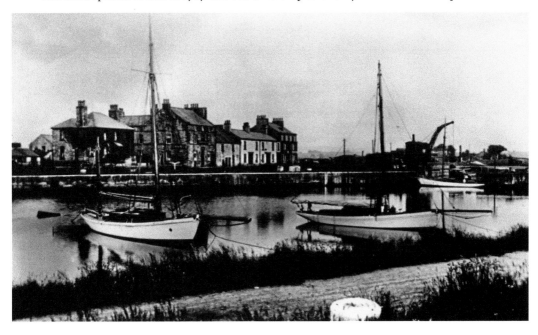

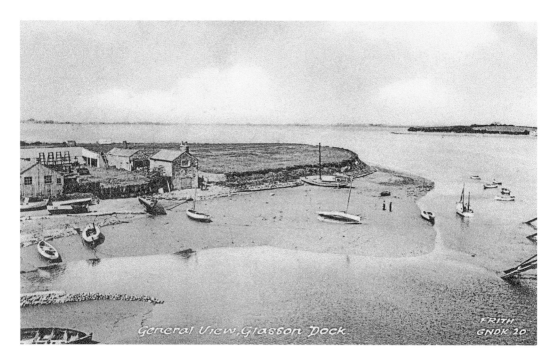

Glasson Dock II

When the Lancaster Canal began being constructed in 1792, it was suggested that a connection between it and the sea could be built. Engineer John Rennie's plans for a Glasson branch formed the basis for an Act of Parliament that was obtained in May 1793, although it was not until 1819 that the plans were revived. Work eventually began in 1823 and was completed in 1826; however, financial problems meant that wharves and warehouses could not be built until the 1830s.

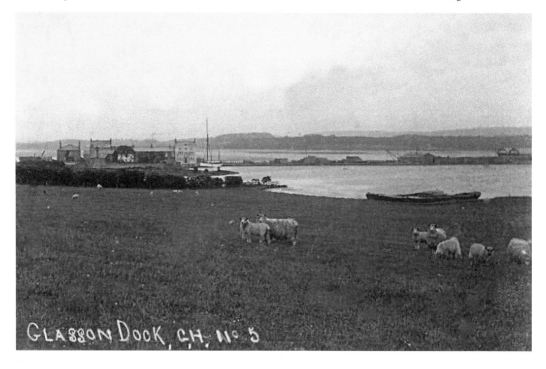

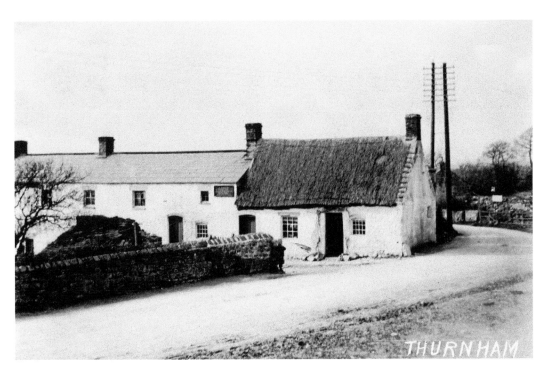

Thurnham

The small village of Thurnham is situated on the south side of the River Lune Estuary, close to the villages of Conder Green and Glasson Dock. It is made up a small number of houses and farms and was formerly served by the London & North Western Railway's Glasson Dock branch line. Thurnham is best known as being the home of Thurnham Hall, an impressive country manor.

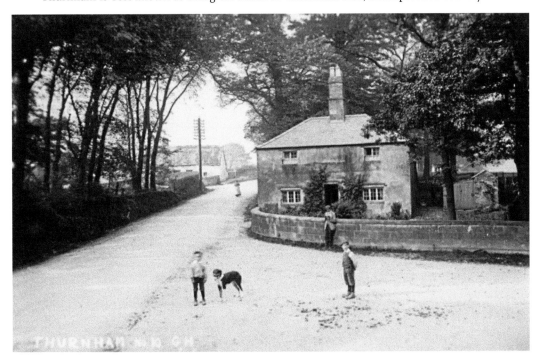

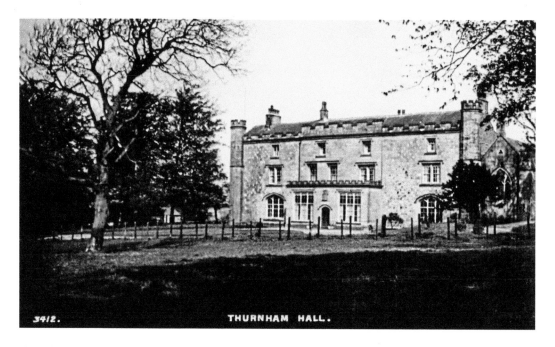

3412. THURNHAM HALL.

Thurnham Hall

Thurnham Hall is a seventeenth-century country house and is home to an imposing Jacobean Great Hall. In the twelfth century the property belonged to the de Thurnham family and then by their descendants until the Grey family. Henry Grey, 1st Duke of Suffolk, sold the estate to Thomas Lonne, a London grocer who subsequently resold it after three years to Robert Dalton from Bispham. Evidence suggests that Robert built the current house shortly after his purchase. Later alterations were made in 1823, replacing the front facade and adding turrets and a parapet. The house continued to be owned by the family until the death of the last descendant, after which the property became derelict until it was sold in the 1970s.

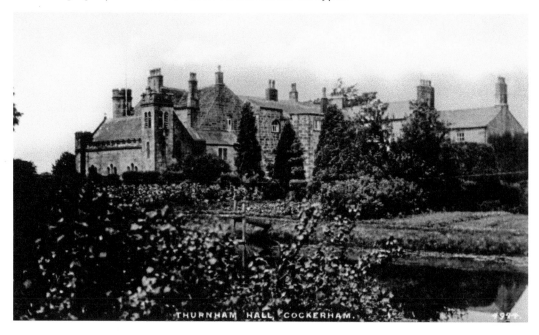

THURNHAM HALL, COCKERHAM.